The Artist's Painting Library

PORTRAITS IN OIL

BY WENDON BLAKE / PAINTINGS BY GEORGE PASSANTINO

WATSON-GUPTILL PUBLICATIONS/NEW YORK

Copyright © 1980 by Billboard Ltd.

First published 1980 in the United States and Canada by Watson-Guptill Publications,
a division of Billboard Publications, Inc.,
1515 Broadway, New York, N.Y. 10036

Library of Congress Cataloging in Publication Data
Blake, Wendon.
 Portraits in oil.
 (His The artist's painting library)
 Originally published as pt. 1 of the author's The
portrait and figure painting book.
 1. Portrait painting—Technique. I. Passantino,
George. II. Title. III. Series: Blake, Wendon.
Artist's painting library.
ND1302.B552 1980 751.45'42 80-19065
ISBN 0-8230-4105-0 (pbk.)

Manufactured in U.S.A.

First Printing, 1980

2 3 4 5 6 7 8 9/86 85 84 83 82

CONTENTS

Portraits in Oil. More portraits are painted in oil than in any other medium. For hundreds of years, oil paint has been the favorite medium of portrait painters—and the key to its popularity lies in the unique character of the paint itself.

What Is Oil Paint? Like every other kind of artists' colors, oil paint starts out as dry, colored powder, called pigment. The pigment is then blended with a vegetable oil called linseed oil—squeezed from the flax plant, whose fibers are also used to make linen. Together the pigment and oil make a thick, luminous paste that the manufacturer packages in metal tubes. It's the oil that produces the buttery consistency that makes oil paint so easy to push around on the canvas. And the oil takes a long time to dry on the painting surface, giving you so much time to work on the picture, to experiment, and to change your mind as often as you like. The linseed oil is called the *vehicle*. But there's another liquid which is equally important in oil painting: a *solvent* that will make the paint thinner and more fluid, then evaporate as the paint dries. This solvent is usually turpentine, though some painters use mineral spirits (or white spirit, as it's called in Britain), which works the same way and is worth trying if you're allergic to turpentine. Oil painters usually add a bit of linseed oil *and* a bit of turpentine to the tube color to make it more "brushable."

Handling Oil Paint. The rich, oily consistency of the color is what oil painters treasure most. The paint is a thick, semi-liquid paste as it comes from the tube, but when you add just a bit of linseed oil and turpentine, the color takes on a creamy consistency which is ideal for the delicate modeling of a face. It's a great delight to blend the lighted front of the forehead into the shadow side of the brow, or add a hint of darkness in the hollow of the cheek with just a few soft strokes. The paint handles like warm butter, so pliable that you can blend one stroke or one color smoothly into another, producing beautiful gradations like colored smoke. If you add still more linseed oil and turpentine, the paint becomes fluid enough to paint crisp lines and precise details, such as strands of hair curling down over the ear, or the glowing highlight in the eye.

Drying Time. The gradual drying time of oil paint is one of its greatest advantages. The turpentine (or mineral spirit) evaporates in minutes, but the oil remains and takes days to dry solid. Actually, the oil never really evaporates, but simply solidifies to a tough, leathery film. Although some colors tend to dry faster than others, your painting does remain moist long enough for you to produce effects that aren't possible in any other medium. You can keep blending fresh color into the wet surface until you get the exact hue that you want. You can go over a passage with the brush, stroke after stroke, until you produce exactly the rough or smooth texture you want. And, if anything goes wrong, you can easily scrape off the wet color with a knife or wipe it away with a rag and turpentine.

Basic Techniques. Before you begin to paint complete portraits in color, it's important to study the human head. So after a quick review of colors, mediums, and painting tools, noted portrait painter George Passantino paints a series of step-by-step demonstrations in black-and-white. First he paints a complete head to show you the basic procedure. Then he shows you how to paint close-ups of the eye, the mouth, the nose, and the ear. These black-and-white demonstrations are important because they show you how the basic forms of the head and features are revealed by the pattern of light and shadow. Study these demonstrations carefully and try painting some heads entirely in black-and-white. This is good practice before you go on to paint in color.

Painting Demonstrations. Following these black-and-white demonstrations, Passantino goes on to demonstrate how to paint ten different portrait heads in color. In these demonstrations, you'll find a wide range of hair and skin colors. You'll learn how to paint the pale skin tones of blond and redheaded sitters; the darker skin tones that are typical of sitters with brown and black hair; the deep tones of black skin and hair; and the oriental sitter's lovely contrast of golden skin and black hair. Each demonstration will show you how to execute the first monochrome brush drawing on the canvas; how to mix and apply all the colors; how to blend the colors and model the forms; and how to add the final touches that give so much vitality to the completed portrait.

Composing, Lighting, Drawing. Following the painting demonstrations, you'll find suggestions about how to direct and pose the sitter. You'll see some typical mistakes in composition—and how to avoid them. You'll study the different ways of lighting a portrait. And you'll watch Passantino demonstrate how to draw portraits in pencil, charcoal, and chalk—and how to make an oil sketch. When you're not painting, devote as much time as you can to drawing. Buy yourself a sketchpad of good, sturdy drawing paper and draw faces whenever you have a spare moment—friends, family, strangers. Drawing is not only fun in itself, but it's the best way to study the most fascinating and varied of all subjects: the human head.

Color Selection. For mixing flesh and hair tones, portrait and figure painters lean heavily on warm colors—colors in the red, yellow, orange, and brown range. As you'll see in a moment, these colors dominate the palette. However, even with a very full selection of these warm colors, the palette rarely includes more than a dozen hues.

Reds. Cadmium red light is a fiery red with a hint of orange. It has tremendous tinting strength, which means that just a little goes a long way when you mix cadmium red with another color. Alizarin crimson is a darker red with a slightly violet cast. Venetian red is a coppery, brownish hue with considerable tinting strength too. Venetian red is a member of a whole family of coppery tones which include Indian red, English red, light red, and terra rosa. Any one of these will do.

Yellows. Cadmium yellow light is a dazzling, sunny yellow with tremendous tinting strength, like all the cadmiums. Yellow ochre is a soft, tannish tone. Raw sienna is a dark, yellowish brown as it comes from the tube, but turns to a tannish yellow when you add white—with a slightly more golden tone than yellow ochre. Thus, yellow ochre and raw sienna perform similar functions. Choose either one.

Cadmium Orange. You can easily mix cadmium orange by blending cadmium red light and cadmium yellow light. So cadmium orange is really an optional color—though it's convenient to have.

Browns. Burnt umber is a rich, deep brown. Raw umber is a subdued, dusty brown that turns to a kind of golden gray when you add white.

Blues. Ultramarine blue is a dark, subdued hue with a faint hint of violet. Cobalt blue is bright and delicate.

Green. Knowing that they can easily mix a wide range of greens by mixing the various blues and yellows on their palettes, many professionals don't bother to carry green. However, it's convenient to have a tube of green handy. The bright, clear hue called viridian is the green that most painters choose.

Black and White. The standard black, used by almost every oil painter, is ivory black. Buy either zinc white or titanium white; there's very little difference between them except for their chemical content. Be sure to buy the biggest tube of white that's sold in the store; you'll use lots of it.

Linseed Oil. Although the color in the tubes already contains linseed oil, the manufacturer adds only enough oil to produce a thick paste that you squeeze out in little mounds around the edge of your palette. When you start to paint, you'll probably prefer more fluid color. So buy a bottle of linseed oil and pour some into that little metal cup (or "dipper") clipped to the edge of your palette. You can then dip your brush into the oil, pick up some paint on the tip of the brush, and blend oil and paint together on your palette.

Turpentine. Buy a big bottle of turpentine for two purposes. You'll want to fill that second metal cup, clipped to the edge of your palette, so that you can add a few drops of turpentine to the mixture of paint and linseed oil. This will make the paint even more fluid. The more turpentine you add, the more liquid the paint will become. Some oil painters like to premix linseed oil and turpentine, 50-50, in a bottle to make a thinner *painting medium*, as it's called. They keep the medium in one palette cup and pure turpentine in the other. For cleaning your brushes as you paint, pour some more turpentine into a jar about the size of your hand and keep this jar near the palette. Then, when you want to rinse out the color on your brush and pick up a fresh color, you simply swirl the brush around in the turpentine and wipe the bristles on a newspaper.

Painting Mediums. The simplest painting medium is the traditional 50-50 blend of linseed oil and turpentine. Many painters are satisfied to thin their paint with that medium for the rest of their lives. On the other hand, art supply stores do sell other mediums that you might like to try. Three of the most popular are damar, copal, and mastic painting mediums. These are usually a blend of natural resin—called damar, copal, or mastic, as you might expect—plus some linseed oil and some turpentine. The resin is really a kind of varnish that adds luminosity to the paint and makes it dry more quickly. Once you've tried the traditional linseed oil–turpentine combination, you might like to experiment with one of these resinous mediums. You might also like to try a gel medium. This is a clear paste that comes in a tube.

Palette Layout. Before you start to paint, squeeze out a little dab of each color on your palette, plus a *big* dab of white. Establish a fixed location for each color, so you can find it easily. One good way is to place your *cool* colors (black, blue, green) along one edge and the *warm* colors (yellow, orange, red, brown) along another edge. Put the white in a corner where it won't be soiled by the other colors.

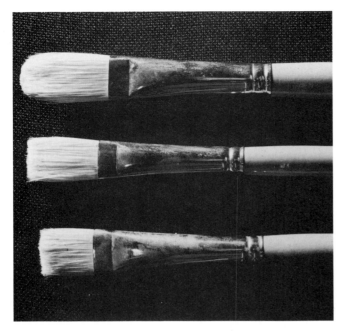

Bristle Brushes. The filbert (top) is long and springy, comes to a rounded tip, and makes a soft stroke. The flat (center) has a squarish tip and makes a more rectangular stroke. The bright (bottom) also makes a rectangular stroke, but the bristles are short and stiff, leaving a strongly textured stroke.

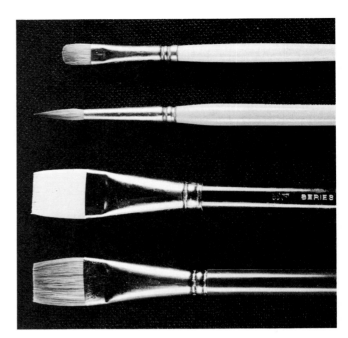

Softhair Brushes. Bristle brushes do most of the work, but softhair brushes are helpful for smoother, more precise brushwork. The top two are sables: a small, flat brush that makes rectangular strokes; a round, pointed brush that makes fluid lines. At the bottom is an oxhair brush, while just above it is a soft, white nylon brush; both make broad, smooth, squarish strokes.

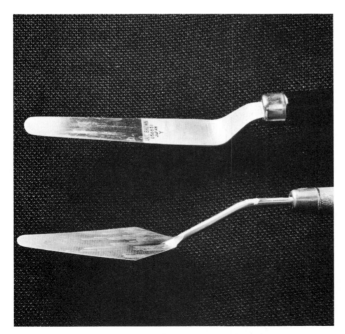

Knives. A palette knife (top) is useful for mixing color on the palette; for scraping color off the palette at the end of the painting session; and for scraping color off the canvas when you're dissatisfied with what you've done and want to make a fresh start. A painting knife (bottom) has a very thin, flexible blade that's specially designed for spreading color on canvas.

Easel. A wooden studio easel is convenient. Your canvas board, stretched canvas, or gesso panel is held upright by wooden "grippers" that slide up and down to fit the size of the painting. They also adjust to match your own height. Buy the heaviest and sturdiest you can afford, so it won't wobble when you attack the painting with vigorous strokes.

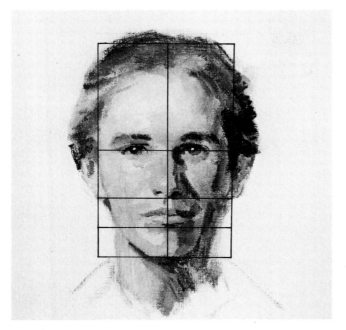

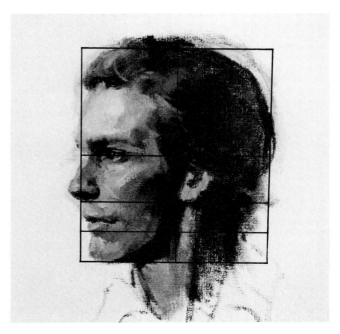

Front View. Seen from the front, the "classic" head is taller than it is wide. The eyes are about midway between the top of the head and the chin. The underside of the nose is about midway between the eyes and the tip of the chin, while the edge of the lower lip is roughly midway between the tip of the nose and the tip of the chin. At its widest point, usually halfway down the head, the head is "five eyes wide."

Profile View. The corner of the eye lines up with the top of the ear. The underside of the nose lines up with the lower edge of the earlobe. The lower lip lines up with the squarish corner of the jaw. The height and the width of the head are roughly equal in this side view. Without the neck, the entire head would fit quite neatly into a square box.

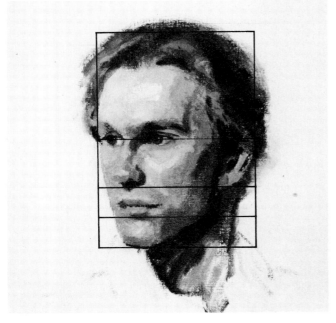

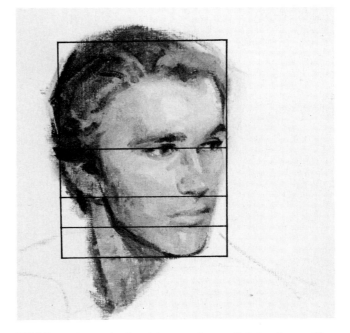

3/4 View. Even when the head turns, the proportions remain essentially the same. The eyes are still halfway down the head and they line up with the top of the ear. The bottom of the nose is still midway between the eyes and the chin, aligning with the earlobe. And the lower lip still falls midway between the tip of the nose and the tip of the chin, lining up with the corner of the jaw.

3/4 View. Now the head is seen from slightly above. You see more of the top of the head. If you draw a line through the corners of the eyes, that line will slant slightly downward from right to left. So will *all* the lines, which are parallel with the line of the eyes. From this angle, the nose looks just a bit longer and you see less of the tops of the eyes.

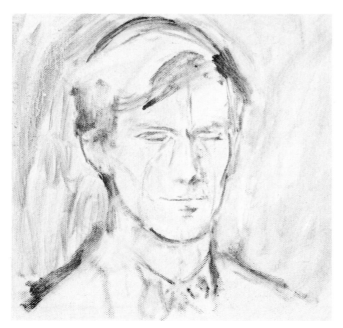

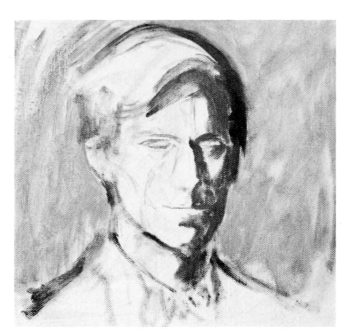

Step 1. A round, softhair brush defines the shapes and proportions of the head. Tube color is thinned with turpentine to the consistency of watercolor. The face is defined as an oval. Just a few lines locate the features. Notice the vertical center line that divides the face symmetrically and helps you to place the features more accurately.

Step 2. Next, a bristle brush defines the shapes of the shadows with broad strokes. The light comes from the left, so there are shadow planes on the right side of the hair, forehead, eyesocket, nose, cheek, lips, jaw, chin, and neck. Now there's a clear distinction between light and shadow. The face already looks three-dimensional.

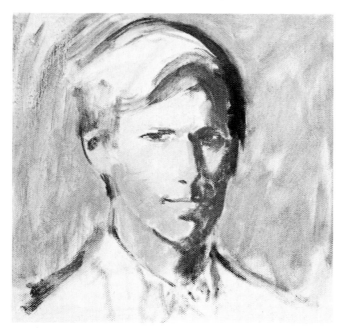

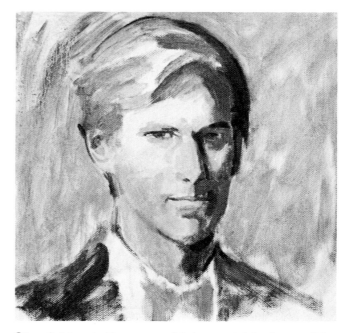

Step 3. A bristle brush covers the lighted area of the face— the forehead, brow, ear, cheek, nose, upper and lower lips, and the lightstruck patch on the cheek that's in shadow. Now the brush begins to add some halftones (lighter than shadows, but darker than lights) on the cheek, jaw, chin, and neck. Dark strokes begin to define the eyes and the ear.

Step 4. More halftones are added to model the forms of the hair, ear, eyes, nose, mouth, and chin. A bristle brush begins to blend darks, lights, and halftones together. Dark strokes sharpen the edge of the features and some touches of darkness bring the shoulders forward.

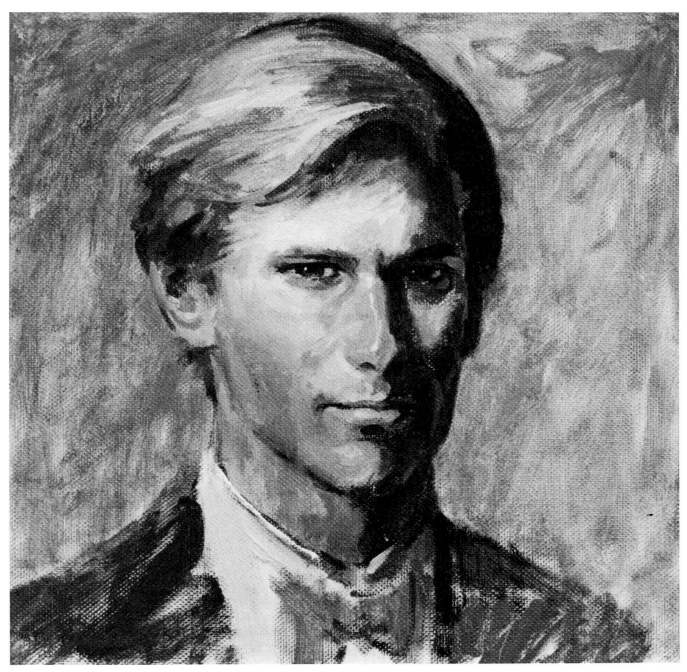

Step 5. In this final stage, a bristle brush strengthens the darks and the lights, blends the tones together, and adds the last touches of detail. Bristle brushes add darker strokes to deepen the shadows and the halftones, then pick up pale color to brighten the lights on the forehead, brow, cheek, lips, and chin. These tones are brushed together with soft, back-and-forth strokes that blur the transition between light, halftone, and shadow. The tip of a round, softhair brush adds the dark lines of the eyebrows, eyes, nostrils, lips, and ear. This same brush adds highlights to the eyes and touches of light along the nose and lips. A bristle brush suggests the texture of the hair with swift, spontaneous strokes that follow the direction of the hair. The background is darkened and the portrait is complete. Remember the sequence of op-erations. The preliminary brush drawing defines shapes and proportions. The darks establish the light and shadow planes of the face. Lights and halftones come next. Darks, lights, and halftones are amplified and brushed together. Finally, the darks, lights, and halftones are further defined and adjusted—and the painting is completed with crisp touches of dark and light that define the features. You may have noticed that the background tone appears early in the development of the picture and is then modified in the final stage, as the head is completed. A professional always remembers that the background is part of the picture—not an afterthought—and he works on the background as he works on the head.

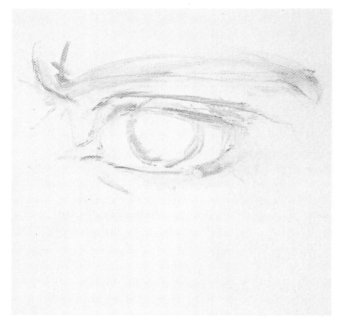

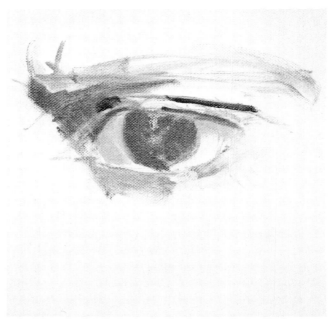

Step 1. A round, softhair brush sketches the lines of the eyebrow, the lid, and the eye itself. Memorize the subtle contours of the lids. Starting from the outer corner, the top lid follows a long, flat curve, turning downward at the inside corner. The lower lid does the opposite, starting from the inside corner as a long, flat curve, then turning upward at the outside corner.

Step 2. A bristle brush scrubs in the darks: the shadow of the inside corner of the eyesocket; the tone of the iris; the shadow lines within the upper lid. Then a paler tone is brushed in to suggest the delicate shadow on the white of the eye and the shadow beneath the lower lid.

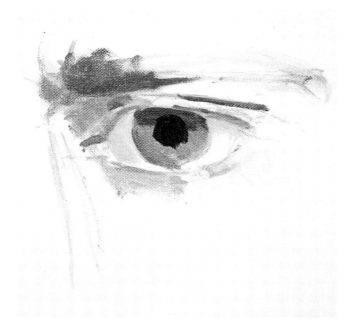

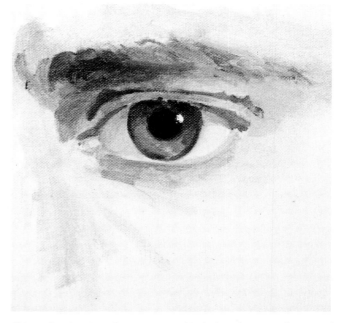

Step 3. The upper lid casts a shadow across the top of the iris—and this tone is added by a flat, softhair brush. This same brush adds the dark pupil. The tip of the round, softhair brush adds the shadow line in the corner of the eye, then paints a slender strip of light along the edge of the lower lid. A bristle brush begins to scrub in the hair of the eyebrow.

Step 4. The tip of a round, softhair brush strengthens and refines the shadows within the upper lid, plus the shadow cast on the white of the eye. This same brush sharpens the rounded shape of the iris and the pupil, adding a brilliant white highlight. The shadows in the eyesocket are strengthened. The round brush extends the eyebrow with delicate, linear strokes.

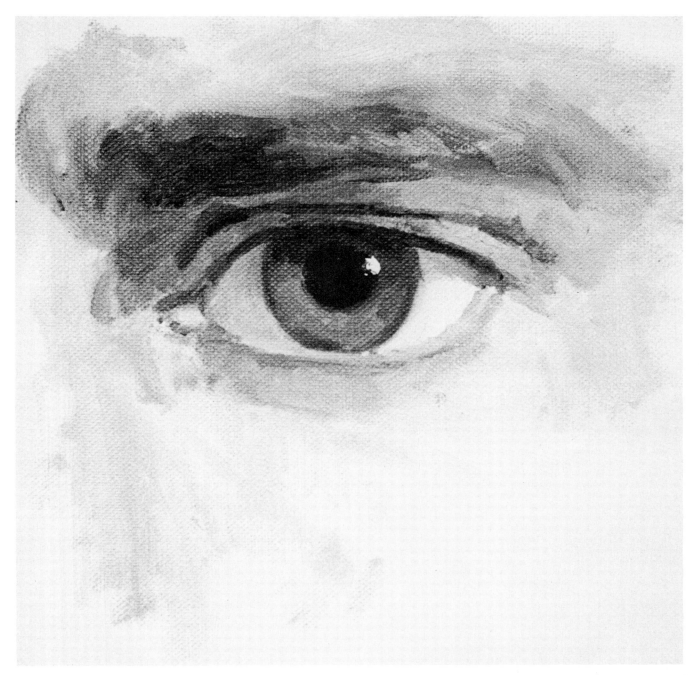

Step 5. Study this enlargement of the completed eye. A bristle brush has added more shadow beneath the brow to make the eyesocket look deeper. A round, softhair brush has strengthened the shadow lines within the upper lid. Notice the modeling of the lights and shadows on the eye itself. The eye is a rounded form, after all, so the lights and shadows should emphasize its curving shape. Thus, the white of the eye is brightly lit at the right, but curves gradually into shadow at the left. The three-dimensional form of the eye is emphasized by the strip of shadow that's cast by the upper lid and curves over the ball of the eye. The sequence of painting operations is the same sequence you've already seen in the step-by-step demonstration of the head: brush lines for form and proportions; broad masses of darks, halftones, and lights; final darks, lights, and details.

Step 1. The brush draws horizontal lines for the top of the upper lip, the division between the lips, and the bottom of the lower lip. It's important to visualize the mouth in relation to the nose and the chin, which are also indicated with quick touches of the brush. A vertical center line divides the face into equal halves and helps you to place the features symmetrically.

Step 2. The darkest notes are placed first—the underside of the upper lip, the shadow beneath the lower lip, and a nostril. Halftones define the planes above and below the lips, including the concave valley that joins the nose and the upper lip. The lightest tones are placed within this valley, at the center of the upper and lower lips, and at the center of the chin.

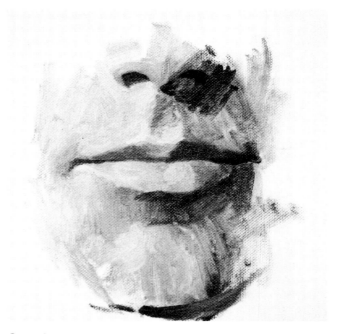

Step 3. Dark strokes are added to suggest the shadow cast by the corner of the nose, plus the shadow on the side of the chin. Halftones are added around the lips and chin. The brush begins to blend these tones together with casual strokes that merge darks, halftones, and lights.

Step 4. The darks are strengthened with precise strokes that sharpen the contours of the lips, nose, and chin. The light planes are made still lighter to emphasize the contrast between light and shadow, making the face look more three-dimensional. A pointed brush sharpens the dividing line of the mouth, deepens the shadow beneath the lower lip, and adds the nostrils.

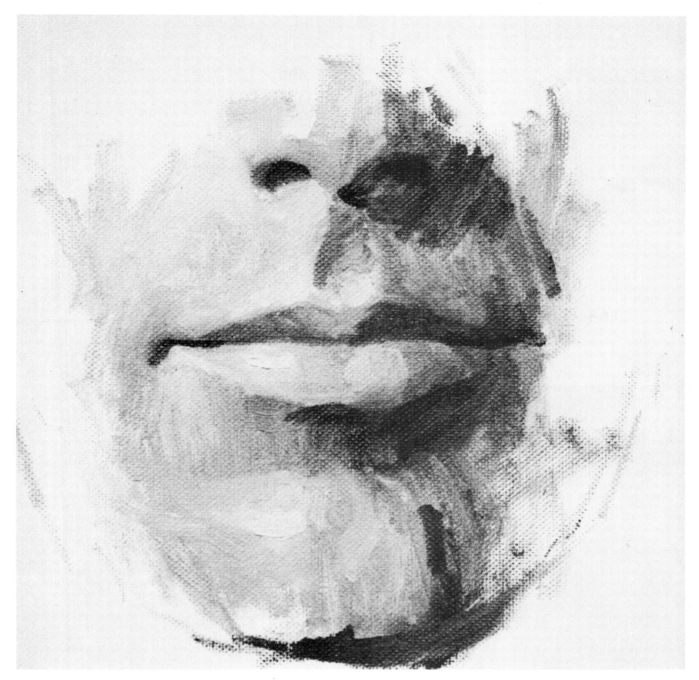

Step 5. In this enlarged close-up of the finished study of the mouth, you can see how the tones have been softened and blended to make the face look rounder and more lifelike. The brush has blurred the edges of the darks to make the nostrils and the lips look softer and rounder. Much of the scrubby brushwork around the mouth has been softened to make the strokes flow together more smoothly. Soft, blurry strokes of light have been added to the lower lip and the chin, which now come forward more distinctly. Notice how the corner of the mouth at the left has been darkened and softened. As you paint the mouth, you'll notice that the upper lip is usually in shadow, while the lower lip tends to catch the light. Beneath the lower lip, there's another pool of shadow. As the chin curves outward, it catches the light, then moves back into shadow as it curves inward at the very bottom.

Step 1. The brush drawing not only defines the bridge of the nose and the nostrils, but also suggests such surrounding structures as the eyesockets and the center line of the upper lip. The lines also make a clear distinction between the shape of the tip of the nose and the "wings" of the nostrils.

Step 2. A bristle brush adds the darks. The light comes from the left and from slightly above, creating deep shadows in the corner of the eyesocket, beside the bridge and tip of the nose, alongside the nostril "wing," beneath the nose, and on the side of the upper lip. The brush also indicates a halftone for the brow above the bridge of the nose.

Step 3. The halftones and the lighter tones come next. The rounded corner of the eyesocket on the lighted side of the face is modeled with a halftone. The nose and the cheeks are painted with lighter tones that are distinctly paler than the surrounding darks.

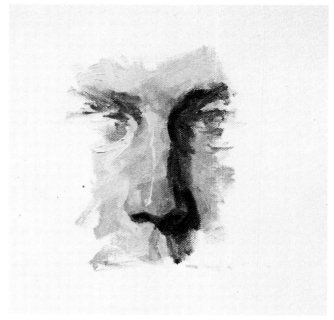

Step 4. Darks and halftones are added to define the shapes of the eyesockets, the shadow side of the nose, the tip, and the nostrils. The tones are gently brushed together to create soft transitions. A softhair brush brightens the bridge of the nose and the cheeks with pale strokes, then carries a slender highlight down the lighted edge of the nose.

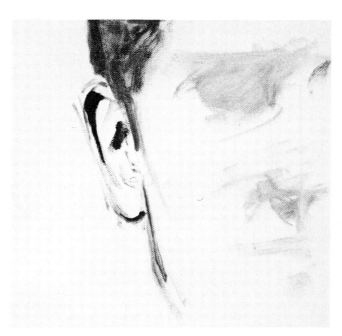

Step 1. The preliminary brush drawing defines the general shape of the ear, then locates the ear in relation to the eye, nose, cheek, and jaw. The curve of the cheek comes right next to the ear. The top of the ear aligns with the corner of the eye, while the lobe lines up with the nose. The angular corner of the jaw is well below the ear and level with the mouth.

Step 2. Dark strokes define the top shadows within the ear, the shadow beneath the lobe, the shape of the hair, and the dark edge of the jaw, which continues up past the lobe. With just these few dark touches, the ear already begins to look three-dimensional.

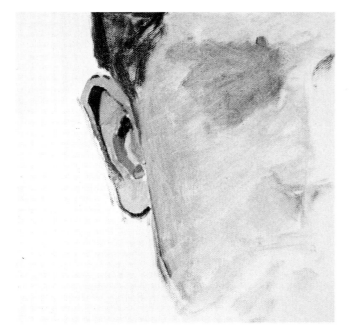

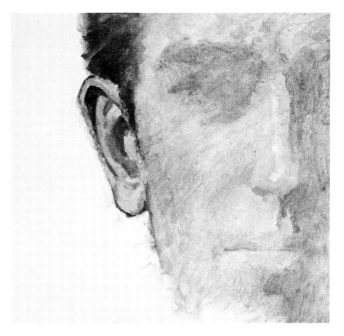

Step 3. The two pools of shadow within the ear are carried downward with strokes of halftone. The rest of the ear is covered with a pale tone that represents the light. Now the planes of the ear are clearly defined in three distinct tones: darks, halftones, and lights. So far, only the major planes of the ear have been defined.

Step 4. Now the brush adds more lights and halftones to define such smaller forms as the rim, the valley just beneath the top rim, and the lobe. A softhair brush blends the edges of the darks with the halftones and the lights. A pointed brush adds touches of darkness beneath the rim, within the hollow of the ear, and at the corner of the lobe, then adds final touches of light.

Buying Brushes. There are three rules for buying brushes. Buy the best you can afford—even if you can afford only a few. Buy big brushes, not little ones; big brushes encourage you to work in bold strokes. And buy brushes in pairs, roughly the same size. For example, if you're painting the light and shadow planes of a face, you can use one big brush for the shadows, but you'll want another big brush, unsullied by dark colors, to paint the skin in bright light.

Recommended Brushes. Begin with a couple of really big bristle brushes, around 1″ (25 mm) wide for painting your largest color area. Try two different shapes: possibly a flat and a filbert, one smaller than the other. Then you'll need two or three bristle brushes about half this size; again, try a flat, a filbert, and perhaps a bright. For painting smoother passages, details, and lines, three softhair brushes are useful: one that's about 1/2″ (25 mm) wide; one that's about half this wide; and a pointed, round brush that's about 1/8″ or 3/16″ (3-5 mm) thick at the widest point.

Knives. For mixing colors on the palette and for scraping a wet canvas when you want to make a correction, a palette knife is essential. Many oil painters prefer to mix colors with the knife. If you like to *paint* with a knife, buy a painting knife with a short, flexible, diamond-shaped blade.

Painting Surfaces. When you're starting to paint in oil, you can buy inexpensive canvas boards at any art supply store. These are canvas coated with white paint and glued to sturdy cardboard in standard sizes that will fit into your paintbox. Another pleasant, inexpensive painting surface is canvas-textured paper that you can buy in pads, just like drawing paper. (Many of the demonstrations in this book are painted on canvas-textured paper.) Later, you can buy stretched canvas—sheets of canvas, precoated with white paint and nailed to a rectangular frame made of wooden stretcher bars. You can save money if you buy stretcher bars and canvas, then assemble them yourself. If you like to paint on a smooth surface, buy sheets of hardboard and coat them with acrylic gesso, a thick, white paint that you can thin with water.

Easel. An easel is helpful, but not essential. It's just a wooden framework with two "grippers" that hold the canvas upright while you paint. The "grippers" slide up and down to fit larger or smaller paintings—and to match your height. If you'd rather not invest in an easel, you can improvise. One way is to buy a sheet of fiberboard about 1″ (25 mm) thick and hammer a few nails part way into the board, so the heads of the nails overlap the edges of the painting and hold it securely.

Prop the board upright on a tabletop or a chair. Or you can just tack canvas-textured paper to the fiberboard.

Paintbox. To store your painting equipment and to carry your gear from place-to-place, a wooden paintbox is convenient. The box has compartments for brushes, knives, tubes, small bottles of oil and turpentine, and other accessories. It usually holds a palette—plus canvas boards inside the lid.

Palette. A wooden paintbox often comes with a wooden palette. Rub the palette with several coats of linseed oil to make the surface smooth, shiny, and nonabsorbent. When the oil is dry, the palette won't soak up your tube color and will be easy to clean at the end of the painting day. Even more convenient is a paper palette. This looks like a sketchpad, but the pages are nonabsorbent paper. You squeeze out your colors on the top sheet. When you're finished, you just tear off and discard the top sheet. Paper palettes come in standard sizes that fit into your paintbox.

Odds and Ends. To hold turpentine, linseed oil, or painting medium, buy two metal palette cups (or "dippers"). Make a habit of collecting absorbent, lint-free rags to wipe mistakes off your painting. Paper towels or old newspapers (a lot cheaper than paper towels) are essential for wiping your brush after rinsing in turpentine.

Furniture. Be sure to have a comfortable chair or couch for your model. Not many people have the stamina to *stand* for hours while they're being painted! If you're working at an easel, you're probably standing while the model sits or sprawls—which means that the model is below your eye level. That's why professional portrait and figure painters generally have a model stand. This is just a sturdy wooden platform or box about as high as your knee and big enough to accommodate a large chair or even a small couch. If you're handy with tools, you can build it yourself. (Of course, you can always work sitting down!) Another useful piece of equipment is a folding screen on which you can hang pieces of colored cloth—which can be nothing more than old blankets—to create different background tones.

Lighting. If your studio or workroom has big windows or a skylight, that may be all the light you need. Most professionals really prefer natural light. If you need to boost the natural light in the room, don't buy photographic floodlights; they're too hot and produce too much glare. Ordinary floor lamps, tabletop lamps, or those hinged lamps used by architects will give you softer, more "natural" light. If you have fluorescent lights, make sure that the tubes are "warm white."

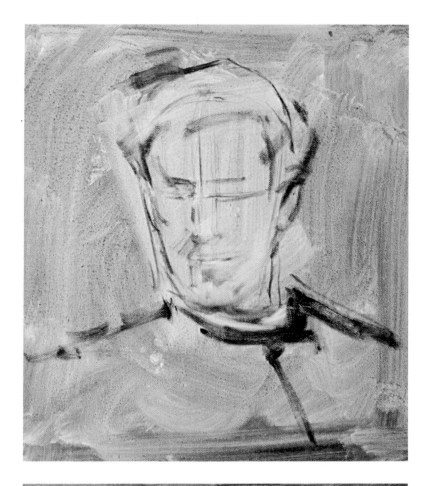

Step 1. A good way to start any portrait is to cover the white canvas with a tone. Against this tone the lights of the face will stand out more clearly, and you'll find it easier to decide how dark to make the darks. This portrait begins with a mixture of raw umber and ultramarine blue thinned with lots of turpentine and rubbed over the canvas with a rag. It's not important for the tone to be smooth; actually, the tone is more interesting if it's rough and irregular. The area of the face is lightened with a clean rag that removes most of the tone, but not all of it. A small bristle brush picks up the same mixture of raw umber and ultramarine blue—diluted with somewhat less turpentine—and sketches the outer shape of the head and hair. A vertical center line is drawn down the middle of the face to help locate the features on either side of the line. The brush establishes the location of the eyes, nose, and mouth with a few horizontal lines, making no attempt to draw the actual shapes of these features. The sketch is completed with several broad strokes for the shoulders and the collar.

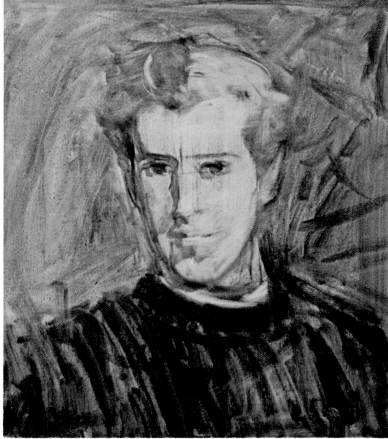

Step 2. More ultramarine blue is added to darken the original mixture, which is still diluted only with turpentine. A small bristle brush draws the shadows on the sides of the brow, cheek, jaw, chin, nose, and lips. One eye socket is filled with shadow. A round softhair brush draws the shadows under the eyelids and the dark shape of the iris. A big bristle brush blocks in the shadow planes of the hair; darkens the background with free, scrubby strokes; and darkens the sweater. A rag, wrapped around a finger, wipes away the light areas of the face and hair, leaving only a faint hint of the undertone applied in Step 1. This monochrome "block-in" establishes the shapes of the face and features, as well as the pattern of light and shadow, before you start to think about color.

Step 3. A big bristle applies the first casual strokes of background color: cobalt blue softened with raw umber and lightened with a touch of white. A small bristle brush goes over the shadows with a rich, warm mixture of raw sienna and Venetian red, diluted with painting medium to a liquid consistency. The brush picks up a thick mixture of raw umber, raw sienna, a touch of cadmium yellow, and white—diluted with just a touch of painting medium—and paints the shadow planes of the hair with short, thick strokes. More cadmium yellow and white are blended into this mixture for the lighted area of the hair, which is painted with curving strokes that suggest the sitter's curls. A few strokes of the cool background tone are brushed over the sweater. More white is added to this tone for the curving stroke of the shadow under the collar. A single curving stroke of white suggests the lighted edge of the collar. Notice that both eye sockets are now in shadow; but the socket on the lighted side of the head is slightly paler than the socket on the shadow side.

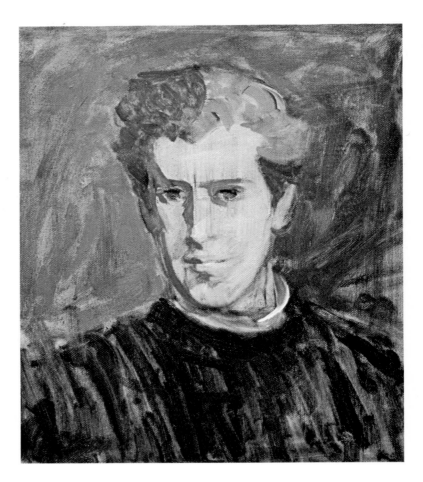

Step 4. A large bristle brush covers the lighted areas of the face with broad strokes of raw umber, cadmium orange, and white, diluted with painting medium to a creamy consistency. These pale strokes are placed right next to the shadows, but the lights and shadows are not blended together at this stage. They're just flat tones. A slightly darker version of this mixture—containing less white—appears on the cheek.

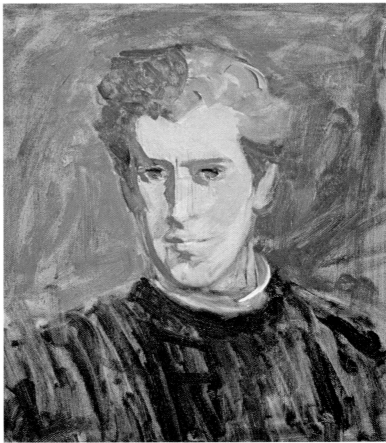

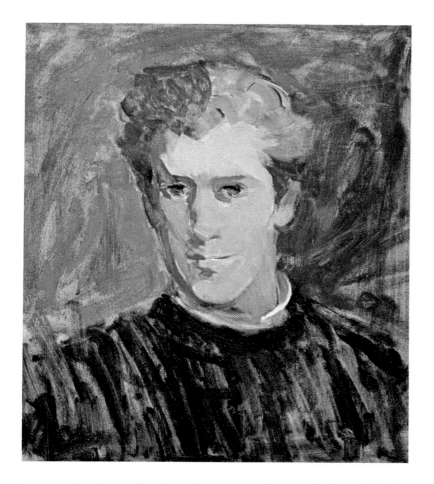

Step 5. Now some halftones begin to appear in the lower half of the face. These tones are darker than the brightly lit forehead, but distinctly lighter than the shadows. The tone on the lighted side of the face is raw umber, cadmium orange, and white. The tone on the shadow side of the face is darker, containing more raw umber and less white. This same mixture is brushed between the eyes to suggest the shadow of the brow; it's brushed into the corners of the eye sockets to make them look deeper and rounder; and it's carried down over the neck. The original shadow tone—raw sienna, Venetian red, and a little white—suggests the hollow of the ear. Here and there the brush blends the light and shadow planes together. You can see this most clearly where the brush has softened the meeting of light and shadow on the forehead and along the side of the nose.

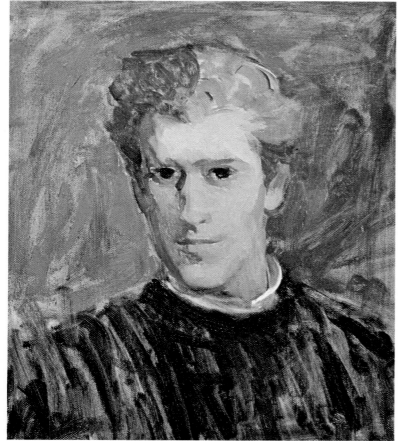

Step 6. Now it's time to refine the drawing. The brush adds more lights and halftones to the cheeks, jaw, and chin. These are brushed softly together to give a sense of roundness to the face. The tip of a round softhair brush strengthens the darks of the eyes with ultramarine blue and burnt umber, then strengthens the shadowy hollow beside the nose with a single stroke of Venetian red and ultramarine blue. The small brush redraws the dark line of the upper lip with the original shadow mixture of raw sienna, Venetian red, and white, using this same mixture to sharpen the shadows around the eyesockets. A single stroke of raw umber, cadmium orange, and white emphasizes the shadowy edge of the lighted cheek at the right.

Step 7. Small brushes move over the face, enriching and deepening the colors and defining the features more strongly. The shadows on the forehead, cheek, jaw, chin, nose, and lips are deepened with a darker mixture of raw umber, Venetian red, and a little white. The shadows beneath the eyebrows are darkened and blended. The darks and halftones of the lower lids are strengthened to make the eyes look rounder. The tip of a round softhair brush draws the dark lines of the eyebrows and the upper lids. The darks of the lips are strengthened with this small, pointed brush. A bristle brush picks up more of the pale mixture of raw umber, cadmium orange, and white to strengthen the light on the forehead, cheek, nose, and chin—then blends this tone softly into the shadows. The tone of the forehead is blended softly into the hairline. Working with the original mixture of raw umber, raw sienna, cadmium yellow, and white, a small bristle brush begins to refine the shape of the hair. A big bristle brush covers the sweater with strokes of burnt umber and ultramarine blue.

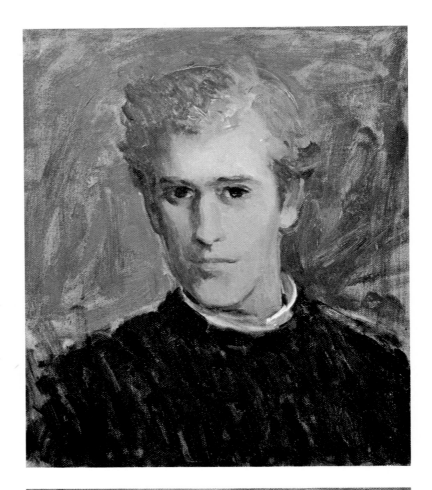

Step 8. Small brushes continue the process of refining and sharpening the forms. The tones within the eye sockets and the lines around the eyes are darkened and drawn more precisely with the tip of a round brush. The whites of the eyes are strengthened with a touch of white delicately tinted with a speck of cobalt blue. Some cobalt blue is also blended into the darks of the iris. Working with raw umber, Venetian red, and a little white, the round brush strengthens the darks around the bridge of the nose, beneath the tip of the nose, and around the mouth. A single stroke of this mixture defines the nostril on the lighted side, deepens the shadow under the chin, and adds a touch of shadow under the lighted earlobe. Thick strokes of raw umber, cadmium orange, and lots of white brighten the forehead, cheeks, and chin. Working with the original hair mixture, a bristle brush darkens and solidifies the shadows of the hair and then begins to define the texture with short, distinct strokes.

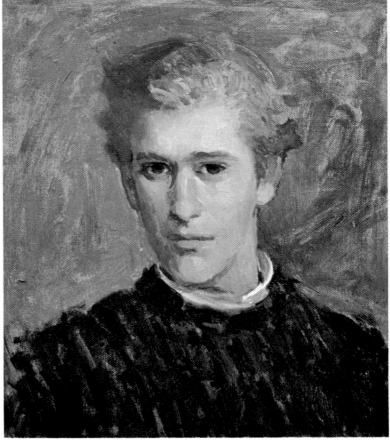

DEMONSTRATION 1. BLOND MAN

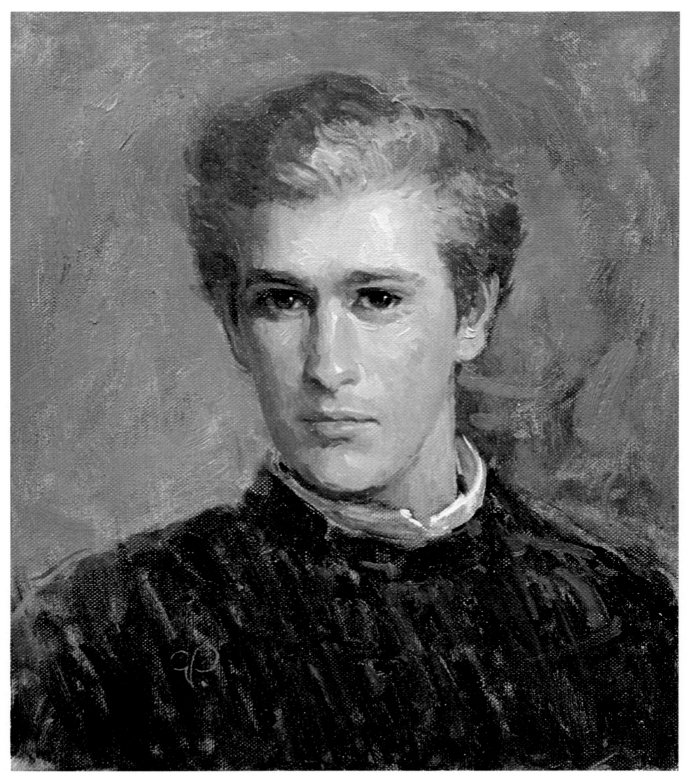

Step 9. The last crisp touches of light and dark—as well as the richest color notes—are saved for this final stage. Thick strokes of cobalt blue, raw umber, and white are freely brushed around the head, while touches of the same mixture are added to the dark sweater. This cool tone heightens the warm hues of the face and hair. Then small bristle and soft-hair brushes travel delicately over the face, enriching the shadows with raw umber and Venetian red; strengthening the lines of the eyebrows, eyes, nostrils, lips, and chin with burnt umber and ultramarine blue; drawing the ear more precisely; adding highlights of pure white to the eyes; and adding luminous strokes of *almost* pure white (tinted with the slightest touch of raw umber and cadmium orange) to the lighted side of the face. A hint of warmth is blended into the lighted cheek. A round brush adds a few strands of hair.

Step 1. A rag picks up a fluid mixture of raw umber and a little cadmium yellow diluted with plenty of turpentine. This mixture is scrubbed lightly over the canvas, leaving the area of the face untouched. A round softhair brush sketches the lines of the face, hair, and shoulders with burnt umber and ultramarine blue, thinned with turpentine to the consistency of watercolor, so the lines flow smoothly. First the brush draws the oval shape of the head, the vertical lines of the hair and neck, and the angular lines of the shoulders. Then a vertical line is carried down the center of the face, and the features are placed on either side of this line with just a few strokes. The purpose of this sketch is simply to establish the shape and proportions of the head, and the locations of the features.

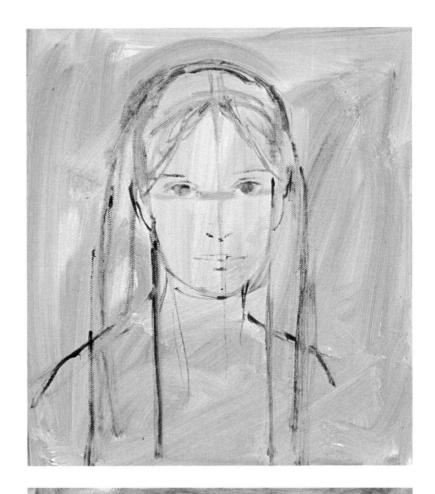

Step 2. A large bristle brush darkens the background with broad, scrubby strokes of burnt umber and yellow ochre. The shadows on the face and neck are delicately brushed in with soft strokes of raw umber, yellow ochre, and white, thinned with painting medium to a fluid consistency. A darker version of this same mixture is scrubbed around the head and down over the shoulders to suggest the hair. A clean rag is wrapped around a fingertip to wipe out the lights of the face and the lighted side of the hair. The tip of a round brush begins to draw the dark lines of the eyelids, the dark shapes of the eyes, the shadowy underside of the nose, and the shadowy lines of the lips. A few strokes of the dark background tones suggest the sitter's jacket.

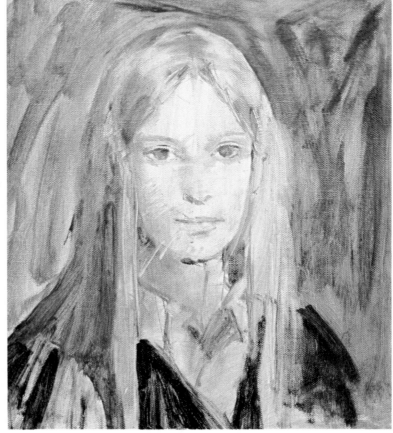

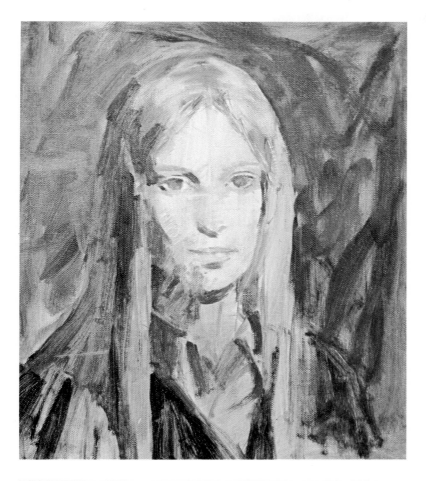

Step 3. A large bristle brush darkens the shadows on the hair and face with rough strokes of raw umber and cobalt blue, warmed with a touch of cadmium red and diluted with painting medium. Notice how a few carefully placed strokes of this mixture deepen the shadows of the eye sockets, the tip of the nose, the lower lip, and the chin. The big brush darkens the background with burnt umber and ultramarine blue to strengthen the contrast between the brightly lit head and the surrounding darkness. The cool shadow of the sitter's collar is indicated with a few straight strokes of cobalt blue, alizarin crimson, and white.

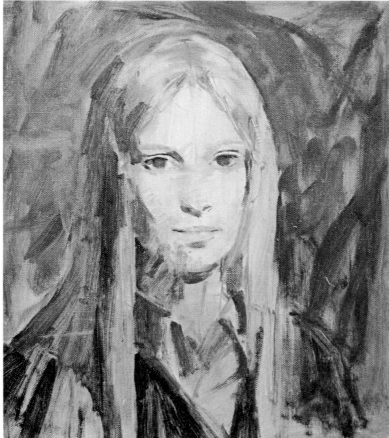

Step 4. The tip of a round brush draws the lines of the eyelids with raw umber and yellow ochre and adds touches of this mixture to define the shadow beneath the nose, the nostrils, and the corners of the mouth. The tip of a small bristle brush adds a touch of cobalt blue and raw umber to the eyes. Just these few notes of darkness make the face look rounder, more solid, and more lifelike.

Step 5. The few strong darks on the face have been clearly stated and now it's time to begin work on the lights. The pale, delicate skin tone of the blond sitter is mixed with raw umber, cadmium red, cadmium orange, and a great deal of white. This is brushed over the forehead, while a slightly darker version of this mixture is brushed over the cheeks, nose, and neck. The light planes of the hair are begun with broad strokes of yellow ochre, raw umber, and white. The first light tones of the blouse are just a few strokes of white tinted with alizarin crimson and cobalt blue.

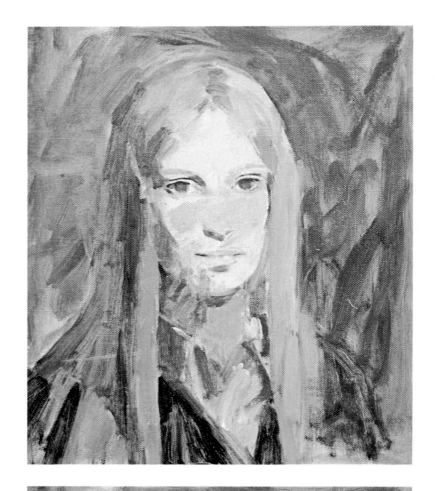

Step 6. The lights are completely covered with a pale mixture of raw umber, cadmium red, cadmium orange, and white. Then the brush mixes the first delicate halftones by adding more raw umber to the mixture. These tones are brushed beneath the eyebrows, between the eyes, and beneath the cheek, where the rounded form turns toward the shadow. A small round brush picks up the original shadow mixture to darken the corners of the eyes and strengthen the underside of the nose. More cadmium red is added to the flesh mixture to begin work on the lips. The lower lip, which catches the light, contains more white. The shadow side of the face is darkened with the original shadow mixture, while touches of this tone darken the corners of the mouth.

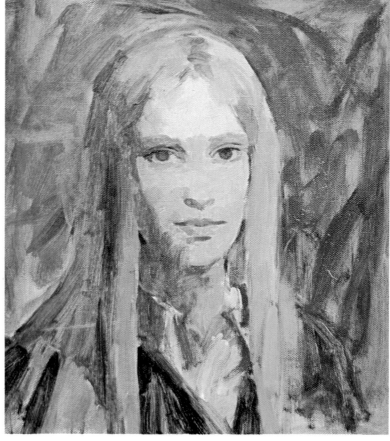

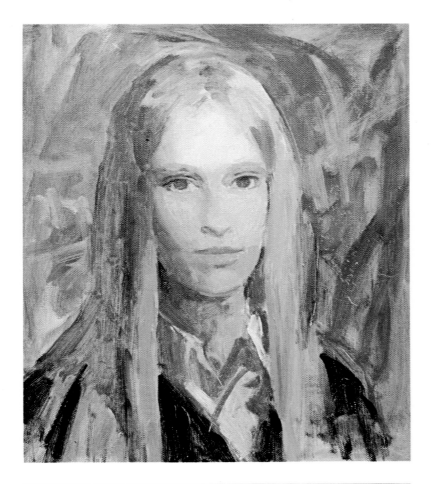

Step 7. The halftones on this face are extremely subtle—almost invisible—and you must look closely to see them. A little more raw umber is added to the flesh mixture, and this tone is brushed in where the light and shadow planes meet at the side of the face; along the side of the nose; and at the sides of the chin, where the jaw turns away from the light. The brush begins to blend the lights, darks, and halftones, which now fuse softly together. The color of the cheeks is heightened with just a little cadmium red. The edges of the lips are softened and blurred into the surrounding tone. The lights and darks of the sitter's blouse are carried further with ultramarine blue, alizarin crimson, and white—more white in the lighted areas. Dark strokes are added to the jacket with burnt umber and ultramarine blue.

Step 8. The shadow planes of the hair are more clearly defined with big, decisive strokes of a bristle brush carrying raw umber, yellow ochre, and a hint of Venetian red to add warmth. More white is added to this mixture, and the brush strengthens the tones of the lighted planes of the hair. The tip of a round brush sharpens the dark lines of the eyelids and adds the pupils with burnt umber and ultramarine blue. It then adds the whites of the eyes and the highlights with white faintly tinted with raw umber. The eyebrows and the eye sockets are darkened with the original shadow mixture. Additional strokes of the light skin tone are added to the face and blended into the edges of the shadows.

Step 9. Small, flat brushes strengthen the shadows on the cheeks, jaw, nose, and eye sockets. The shadow beneath the chin and the dark tone on the neck are deepened with this mixture. The lower lids are darkened to make the eyes more prominent. The lips are enriched with more cadmium red and white and then brightened with a highlight on the lower lip. Notice how a touch of the rag wipes away some color from the jaw and from the shadow side of the hair to suggest reflected light. The lighted side of the hair is solidified with thick touches of raw umber, yellow ochre, and lots of white. A few cool strokes of cobalt blue, raw umber, and white are scrubbed over the warm tone of the background, which becomes more subdued and is less likely to compete with the luminous tones of the hair and face.

Step 10. The hair is developed with thick, creamy strokes of yellow ochre, raw umber, a hint of cadmium orange, and white, diluted with just enough painting medium to make the color flow smoothly. The wet strokes of the shadows—which obviously contain more raw umber than the lights—are placed side-by-side with the lighter strokes. The strokes overlap slightly and blend as the brush moves. The hair at the top of the head is painted with curving strokes, while the hair at the sides of the face is painted with straight, vertical strokes. The tip of a round brush continues to darken the corners of the eyes very gradually; darkens the brows; and adds two dark touches for the nostrils. The color of the cheeks is graduall heightened by blending in cadmium red and white. The dark tones of the jacket are completed with ultramarine blue and burnt umber.

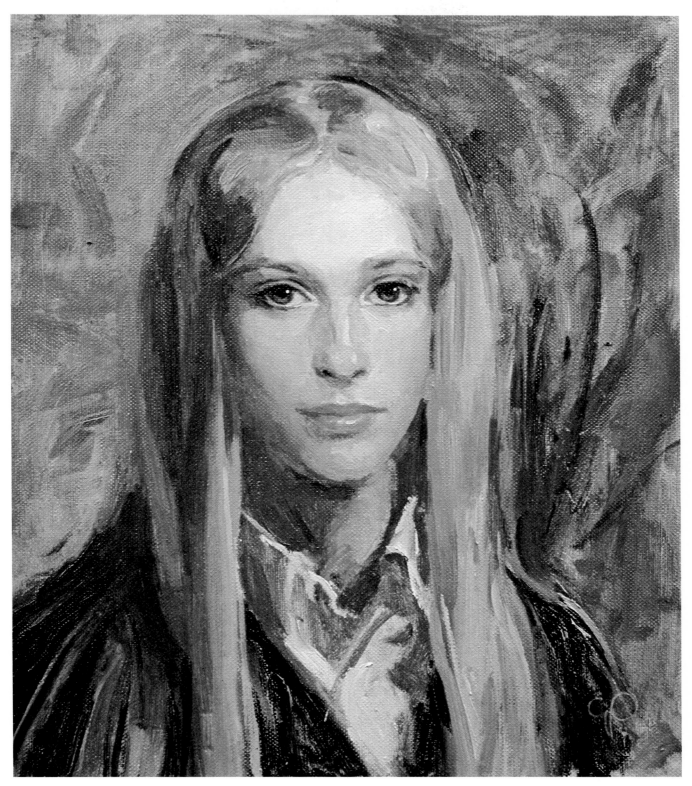

Step 11. The last few touches are added with small softhair brushes that soften the edges of the eyes, sharpen the contours of the lips, and strengthen the lines of the nose. Highlights—pure white tinted with a little flesh tone—are carried down from the bridge of the nose, placed at the tip, carefully located above the upper lip, and finally placed on the chin. Pale strokes are added to the inner corners of the eyes to make the lids look more luminous. A big bristle brush adds more strokes of the cool background tone; by contrast, these strokes heighten the golden tone of the hair.

Step 1. Burnt umber and a little cadmium orange are blended on the palette, diluted with turpentine, and scrubbed over the canvas with a rag. A small bristle brush picks up the same mixture—diluted with less turpentine, to draw the outer contours of the face, head, and neck. Then the tip of a round softhair brush draws the vertical center line of the face and the horizontal guidelines that locate the features. (These lines are very light and will quickly disappear as the painting progresses.) Then a softhair brush quickly indicates the features with a few heavier lines. The features are not drawn precisely. It's their location—and the general proportions of the head—that are most important.

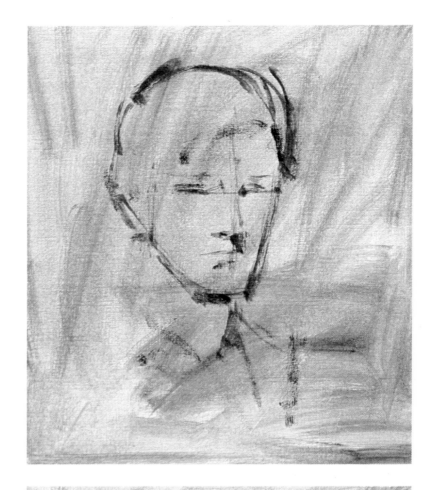

Step 2. A bristle brush blocks in the dark tone of the hair and then goes on to suggest the pattern of light and shadow on the face. The eye sockets are filled with shadow. The brush carries dark strokes down one side of the nose, from the lower edge of the nose down to the upper lip, beneath the upper and lower lips, and beneath the chin. A single dark stroke indicates the hollow of the ear. And the brush scrubs some lighter tones over the forehead, down the shadow side of the face and neck, and beneath the collar. The brush is still working with the original mixture of burnt umber, cadmium orange, and turpentine. The preliminary sketch is completed.

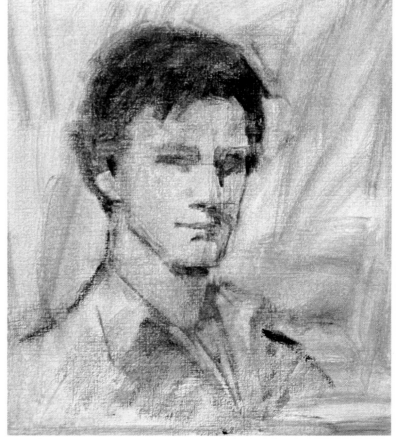

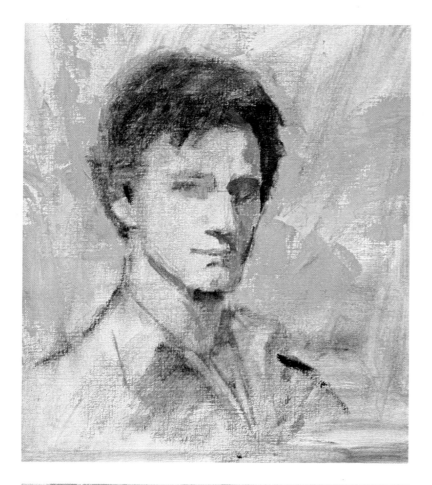

Step 3. Now a bristle brush begins to work with richer color. The shadow side of the head is painted with a mixture of raw umber, raw sienna, Venetian red, and white. This color runs from the brow down to the chin and reappears on the neck. Notice that the lighted side of the head is now paler than in Step 2; it's been wiped with a rag wrapped around a finger. The first background tones are broadly applied with a painting knife, carrying a mixture of burnt umber, yellow ochre, and lots of white. You can see this tone just above the shoulders, beside the dark cheek, and behind the neck. By placing the first strokes of background color side-by-side with the cheek, the artist can determine how dark to make the shadow side of the cheek and how light to make the background. Always start work on the background early; never save it for the very end.

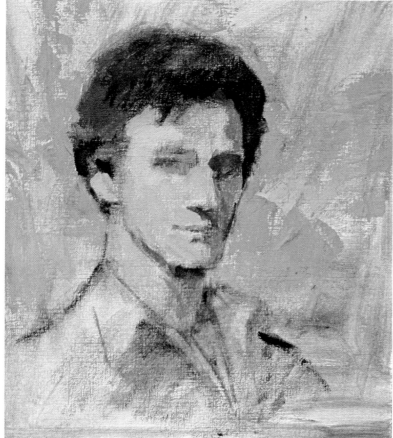

Step 4. A bristle brush covers the lightest areas of the face with a mixture of raw umber, raw sienna, Venetian red, and white. This is the same mixture used for the shadow side, but here it contains more white. Notice that a patch of forehead has been left untouched; this is where the biggest halftone will appear. Just above the ear the brush begins to place some solid color on the hair—a mixture of burnt umber, cadmium orange, and white. Look closely at the lower part of the face and you'll see that the color of the cheek is warmed with an extra touch of Venetian red.

Step 5. Next come the halftones that fall between the lights and shadows. Working with the same mixture of raw umber, raw sienna, Venetian red, and white, a bristle brush covers the patch on the forehead. Then the brush moves into the eye socket on the lighted side of the face and adds halftones to the nose, lips, chin, and neck. You can see clearly that these halftones fall right between the lights and shadows painted in Steps 3 and 4. The tones are simply flat patches of color; they're not blended together yet. A few strokes of white and raw umber suggest the brightly lit collar.

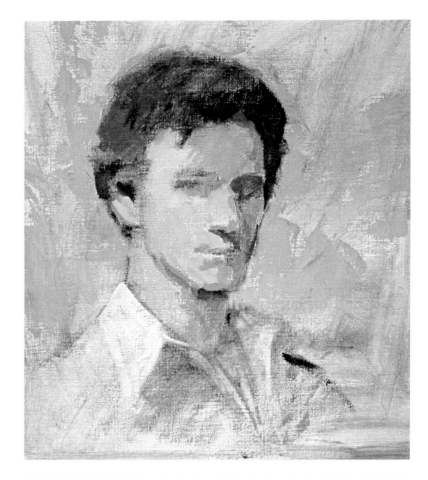

Step 6. The tip of a small brush places a few strokes of burnt umber and ultramarine blue, lightened with just a hint of white, to indicate the eyebrows, the shadow lines of the upper lids, and the dark patches of the eyes themselves. Working with the light and halftone mixtures—raw umber, raw sienna, Venetian red, and varying amounts of white—the tip of a small bristle brush defines the shape of the mouth. Now you can see the dark plane of the upper lip and the lighted plane of the lower lip more clearly. It's easy to see the three basic *values*, as they're called: darks, halftones, and lights. And the face really comes alive as the brush places those few strokes that transform the shadowy eye sockets into eyes.

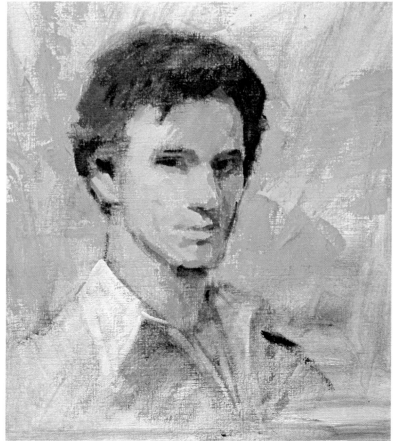

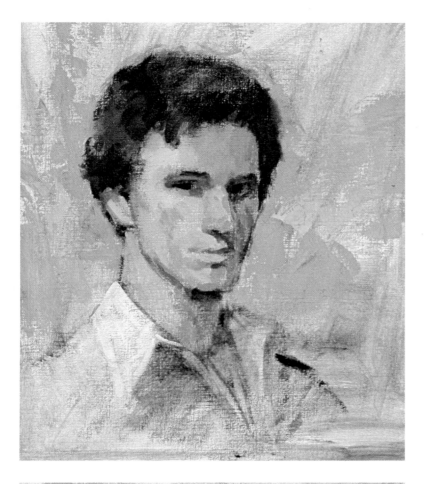

Step 7. Now the brush begins to blend some of the tones. With back-and-forth strokes the brush joins the darks, halftones, and lights on the forehead. More halftones are added to the nose and lower lip, plus the cheek and jaw on the lighted side of the face. A touch of cadmium red, softened with plenty of white, adds a ruddy tone to the cheek. The shape of the eye socket, on the lighted side of the face, is strengthened with short, decisive strokes of shadow tone. A shadow is added where the hair overlaps the ear. A round softhair brush strengthens the darks of the hair with short, curving strokes of burnt umber, ultramarine blue, and a little white.

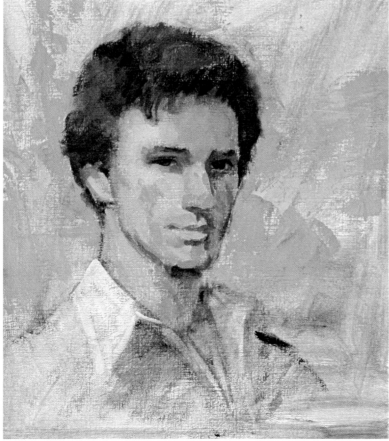

Step 8. Round and flat softhair brushes continue to sharpen the features with small, precise strokes. On the shadow side of the face the eye socket is filled with tone, and a line of shadow redefines the side of the nose. Dark strokes clarify the shapes of the tip of the nose, the nostril, the upper lip, and the shadow side of the jaw. A touch of halftone is scrubbed into the shadow side of the face, which now looks more luminous. The bristle brush now scrubs in the lighter tones of the hair with burnt umber, ultramarine blue, and more white.

Step 9. A small bristle brush moves back into the shadow areas to enrich them with thick strokes of rich color. These strokes are the original mixture of raw umber, raw sienna, Venetian red, and white. You can see variations in the color of these strokes, which are sometimes lighter, sometimes darker, sometimes warmer, and sometimes more subdued. These variations are produced by very slight changes in the proportions of the mixture—such as adding an extra touch of Venetian red to the warm tone on the brow or an extra touch of raw umber to strengthen the darks of the eye sockets. As the shadow side of the face is strengthened, the brush defines the contours of the cheek and jaw more precisely. The shadow tones on the neck and chest are also covered with thick, rich color. A few touches of light color begin to define individual locks of hair. The tip of a round brush suggests the whites of the eyes.

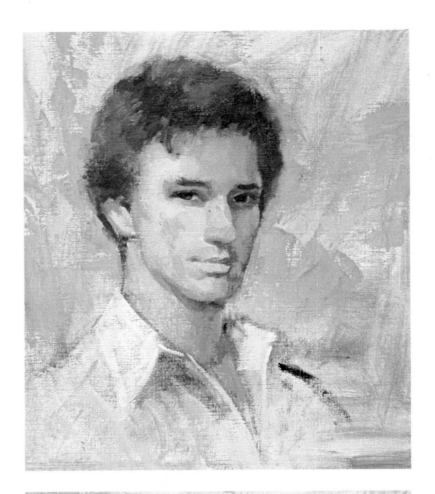

Step 10. More white is added to the flesh mixture, and this pale, bright tone is blended into the lighted side of the face. These strokes make the skin more luminous and heighten the contrast between light and shadow. The pale tones are not smoothly blended, but individual strokes are allowed to stand out; you can see them on the forehead, just above the eye; on the cheek, just below the eye; on the side of the nose; and on the chin. The tip of a round brush begins to sharpen the details of the eyes. The cool shadows beneath the collar are quick, broad strokes of cobalt blue, raw umber, and white.

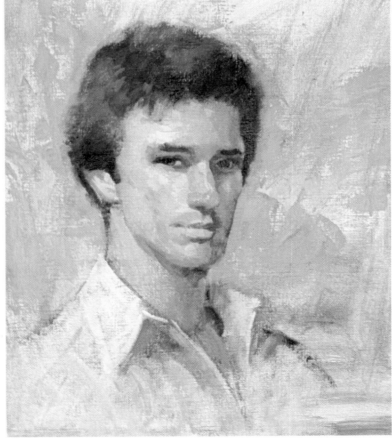

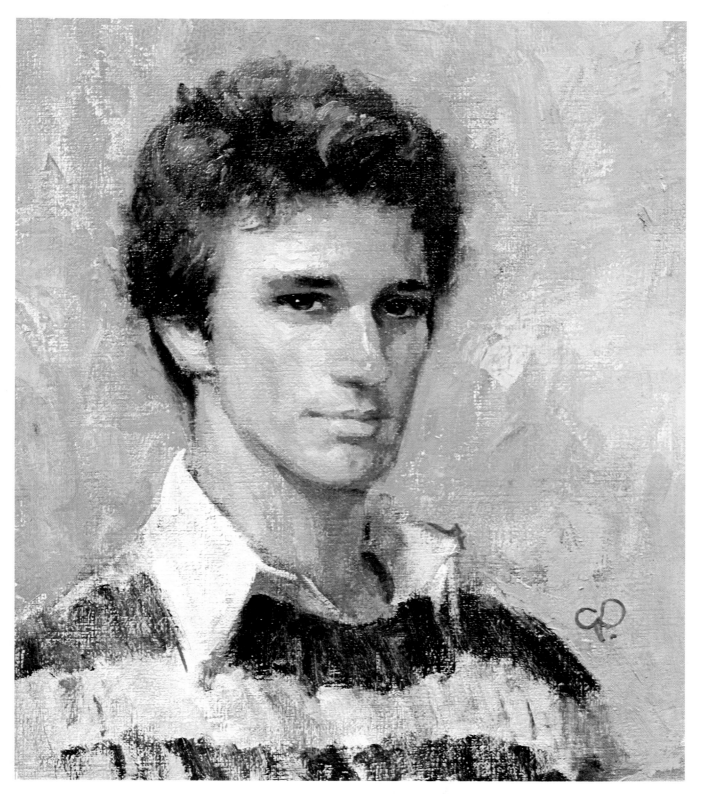

Step 11. A big bristle brush enriches and completes the background with rough strokes of raw umber, raw sienna, cadmium orange, and white. Notice that the background tone is strongest around the face. A round softhair brush completes the hair with pale strokes of raw umber, raw sienna, and white, and darker strokes of burnt umber, ultramarine blue, and white. Small sable brushes sharpen the details of the features. The curves of the eye sockets are darker and more precise. Now you can see the pupils of the eyes and tiny highlights in pure white. The stripes of the sweater are suggested with broad, casual strokes of the same mixture that appears in the hair.

Step 1. The overall tone of this portrait will be cool, so a rag picks up a mixture of cobalt blue, raw umber, and turpentine to cover the bare canvas. This same mixture is used to draw the outlines of the head, hair, neck, shoulders, and dress. A vertical center line divides the face. The eyes are carefully placed on either side of this line, while the nose and mouth are placed right on the line.

Step 2. The dark background is covered with quick, rough strokes of cobalt blue, raw umber, and white. Now the paint is thick and creamy, thinned with medium instead of turpentine. The dark, warm tone of the hair is suggested with a few strokes of raw umber, cobalt blue, and a little white. Some white is added to the background tone—and this mixture is used to scrub in a few strokes that suggest the dress.

Step 3. The shadow side of the head, neck, and shoulder are suggested with just a few broad strokes of a big bristle brush. The shadow tone is a mixture of raw umber, cobalt blue, a touch of cadmium red, and white. Notice how these strokes overlap the hair. Then the first few hints of pale flesh tone are brushed across the face and chest—a delicate mixture of raw umber, cadmium red, cobalt blue, and lots of white. Now the portrait has clearly defined planes of light and shadow.

Step 4. The lighted planes of the face are strengthened with heavier strokes of the pale mixture that first appeared in Step 3. The pale tones of the forehead, cheeks, shoulder, and chest are now clearly defined. Soft halftones are brushed between the lights and shadows. These halftones are the same mixture as the lights—raw umber, cadmium red, cobalt blue, and white—but they contain less white and less cadmium red. These halftones are so subtle that they're only a bit darker than the lights. You can see them most clearly on the brow, cheek, chin, and neck. A small softhair brush blends more cobalt blue into the shadow tone and adds darks to the eyebrows, the eyes, and the underside of the nose. An extra touch of cadmium red is blended into the flesh mixture to suggest the warmth of the lips. A touch of white is blended into the dark background mixture to paint the shadow side of the dress with broad strokes of a big bristle brush.

Step 5. A flat softhair brush begins to blend the whites, halftones, and shadows with delicate, back-and-forth strokes. As the pale tones are brushed into the darks, the shadow side of the face becomes softer and paler. The lighted planes of the face and chest are strengthened with thicker strokes of the original flesh mixture; these strokes are brushed out smoothly. The shape of the hair is solidified with heavier strokes of raw umber, yellow ochre, a little cobalt blue, and white. A round softhair brush picks up the hair mixture to sharpen the lines of the eyebrows and the eyelids. The round shapes of the iris are carefully redrawn, as are the shape of the nostril and the dark line that divides the lips.

Step 6. Flat softhair brushes continue to blend the lights, halftones, and shadows. Now the darker tones of the neck and shoulder flow softly into the paler tones of the chest. There's also a softer transition between light and shadow on the brow and jaw. The contours of the eyes are darkened; the dark pupils appear. A single pale stroke defines the lighted front plane of the nose, and a highlight is added to the tip. The nostril and the side of the nose are drawn more precisely. The upper lip is darkened, while more distinct shadows appear beneath the lower lip and the chin.

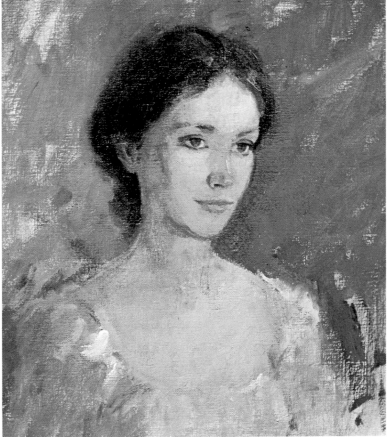

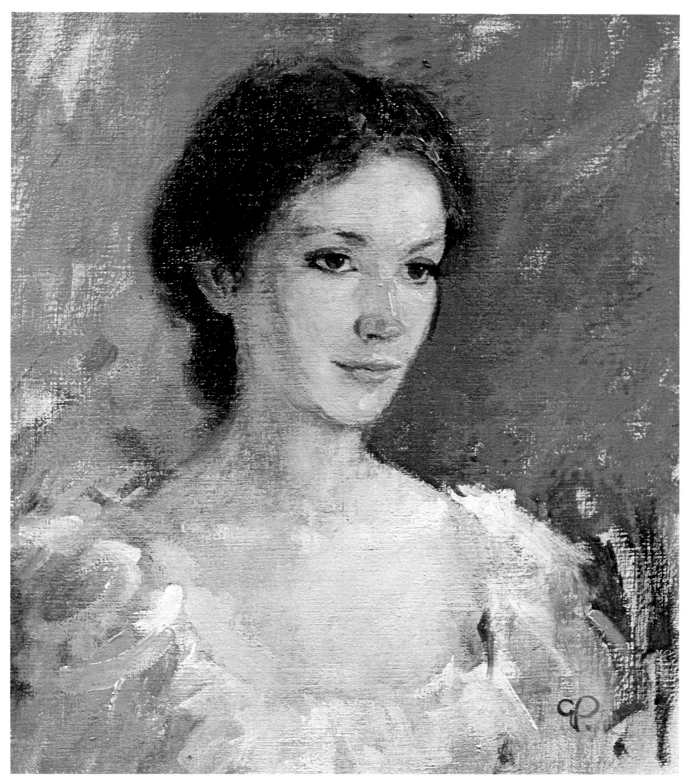

Step 7. The lighted areas of the hair are heightened with the original mixture plus a bit more white, while the background is darkened to emphasize the lighted side of the face. Thick strokes of the palest skin tone make the face, neck, and chest more luminous. More white is added to this tone for the highlights that appear on the forehead, nose, lips, and chin. A dark line is drawn between the lips. Some halftone is lightly rubbed into the shadow side of the face, which now becomes more delicate and transparent. The lighted areas of the dress are completed with rough strokes of white tinted with background color.

Step 1. The canvas is toned with a rag that carries raw umber diluted with turpentine. A clean corner of the rag wipes out the lighted area of the face, neck, shoulder, and chest. Then the preliminary sketch is completed with raw umber. It's instructive to compare this sketch with the preliminary brush drawing for Demonstration 4. Because the painting of the brown-haired woman has very little contrast between light and shadow, the brush drawing simply defines the shapes and then stops. In this painting of a red-haired woman, there are very clearly defined light and shadow planes, which are carefully rendered in the brush drawing.

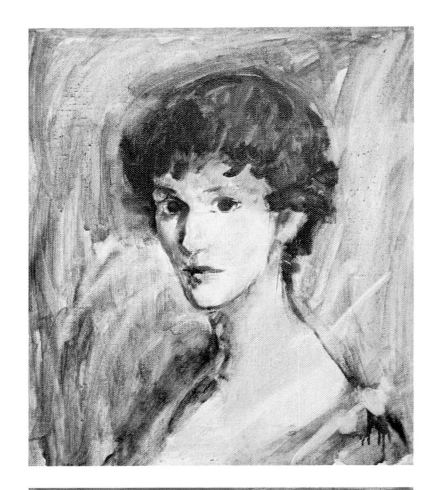

Step 2. The background color is blocked in with broad strokes of viridian, ultramarine blue, burnt umber, and white. This tone completely surrounds the head and establishes the sharp contrast between the dark background and the brightly lit skin. A small bristle brush adds the shadows with a mixture of raw umber, burnt umber, cadmium red, and white. Two variations of the same mixture are used to paint the hair with short, squarish strokes: the dark strokes contain more burnt umber and the light strokes contain more cadmium red. The dark at the center of the eye is the same dark tone that appears in the hair. The color of the dress is quickly scrubbed in with broad strokes of cobalt blue, alizarin crimson, and white.

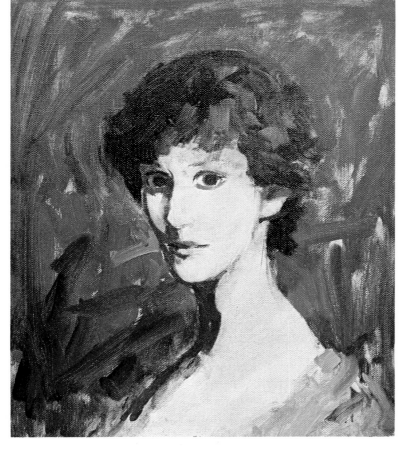

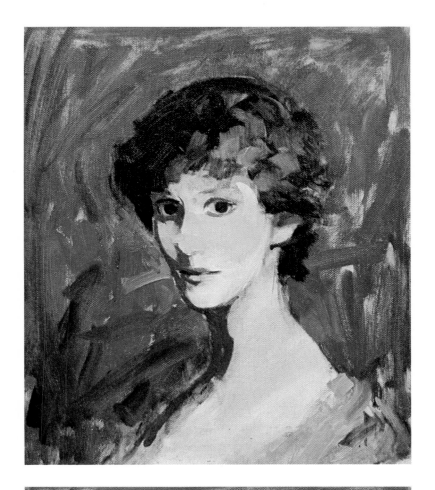

Step 3. The lighted tones of the skin are brushed in with a creamy mixture of raw umber, burnt umber, cadmium red, and white—actually the same mixture as the hair, but with much more white and diluted with painting medium to make the color flow smoothly. The strokes across the center of the face contain a little more cadmium red to heighten the tone of the cheeks and nose. Notice that the brush leaves the halftone areas of the face untouched—the forehead and lower jaw.

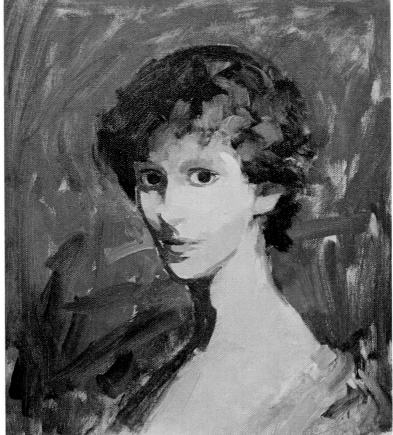

Step 4. A slightly darker version of the flesh tone—containing less white—is brushed across the forehead, the underside of the nose, the undersides of the cheeks, and the lower jaw. These are the subtle halftones that fall between the lights and the shadows. A little more white is added to this halftone mixture, which is then brushed downward over the neck and chest. The eye socket on the lighted side of the face is darkened. This same tone is carried down the back of the neck where the form turns away from the light. More cadmium red is added to the halftone mixture for the color of the lips. As usual, the upper lip is darker because it's in shadow.

Step 5. A flat softhair brush blends together the lights, halftones, and shadows on the face. Now the head begins to take on a soft, rounded quality. Notice how the edges of the hair are blurred so that the dark areas of the hair seem to melt away into the dark background. The soft-hair brush travels down the neck and chest to blur the meeting of light and shadow. Compare the flat patches of color in Step 4 with the soft, blended tones of Step 5. A round softhair brush moves carefully around the eyes to darken the lids and then adds the whites to the eyes with pure white faintly tinted with the pale fleshtone. The dark hair is carried down the back of the neck and softly blended into the skin.

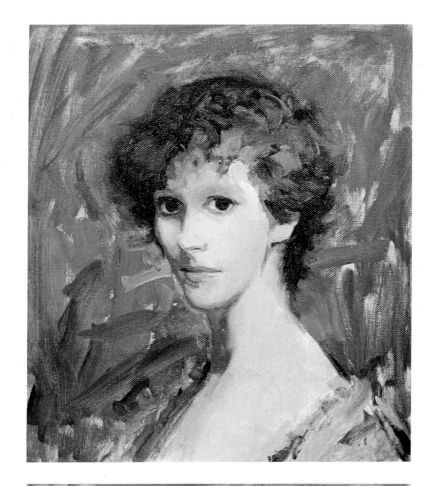

Step 6. The tip of the round softhair brush continues to define the eyes with the same mixture used for the dark areas of the hair. Crisp lines are drawn for the shadows of the lids, and the eyebrows appear for the first time. A mixture of ultramarine blue, viridian, burnt umber, and a little white is blended into each iris. The small brush also sharpens the shapes of the lips and adds some of the lip tone to the cheek. The shadow on the side of the nose is darkened along with the shadow beneath the lower lip. More white is blended into the pale flesh mixture, and this tone is carried over the lighted areas of the face with thick, creamy strokes.

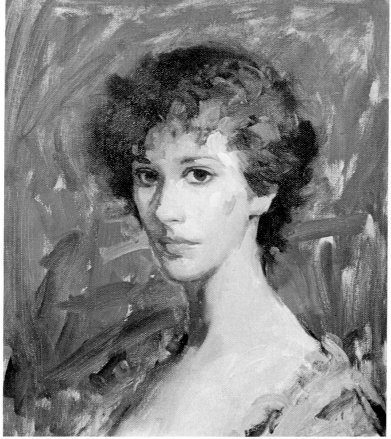

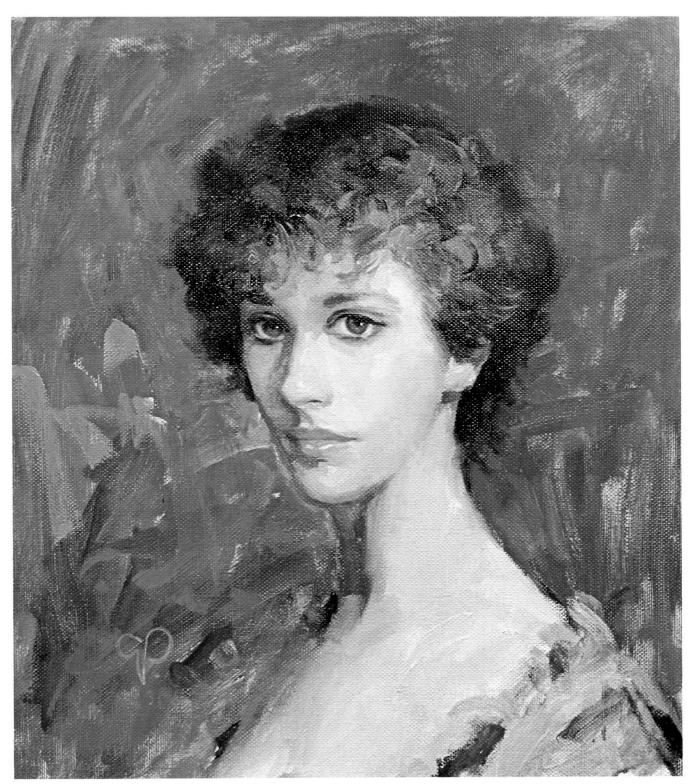

Step 7. More white is blended into the background mixture, and a large bristle brush travels over the background to soften the distracting strokes. With short, curving strokes the tip of a round brush suggests individual locks of hair. The pupils of the eyes are added with burnt umber and ultra-marine blue, followed by a tiny dot of pure white for the highlight. A flat softhair brush blends the lighted side of the face, neck, and chest to soften the thick strokes applied in Step 6. And the tip of the round brush applies highlights to the nose, cheek, lips, and chin.

Step 1. The canvas is toned with a mixture of burnt umber and cadmium red diluted with turpentine to the consistency of watercolor. The shape of the face is drawn with the tip of a round softhair brush, which then indicates the features. This is done with burnt umber and ultramarine blue. A small bristle brush uses the same mixture to draw the hair with free strokes, and then the brush adds a few touches of shadow to the brow, cheek, nose, upper lip, and chin. The bristle brush picks up the background mixture to suggest the shoulders and the collar with a few big strokes.

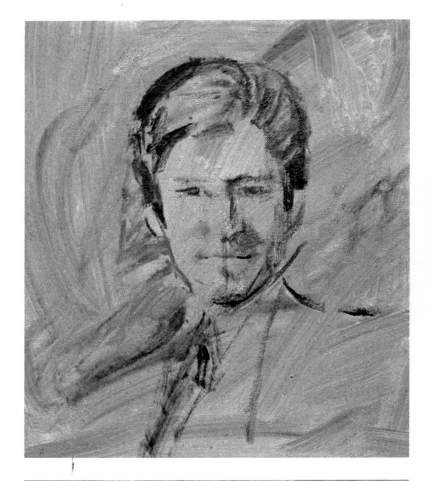

Step 2. A bristle brush blocks in the shadows with a thicker, creamier mixture of raw umber, a little raw sienna, and white diluted with painting medium. You can now see solid shadow tones on the forehead, cheek, jaw, eye socket, nose, lips, and ear. The shadow planes of the hair are also brushed in with burnt umber and ultramarine blue, a combination which makes a beautiful dark tone which is more colorful than black. The head is strongly lit from the left; this accounts for the shadow cast by the nose. A thicker version of the background color—burnt umber, cadmium red, and white—is scrubbed in around the head. It's important to do this early so you can see how the colors of the head relate to the background tone.

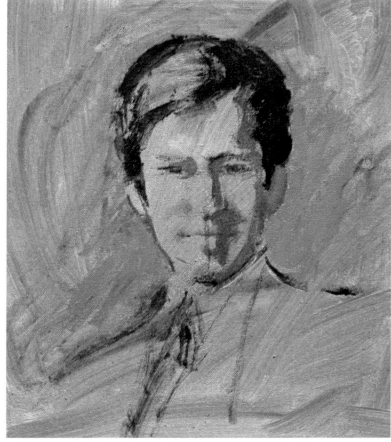

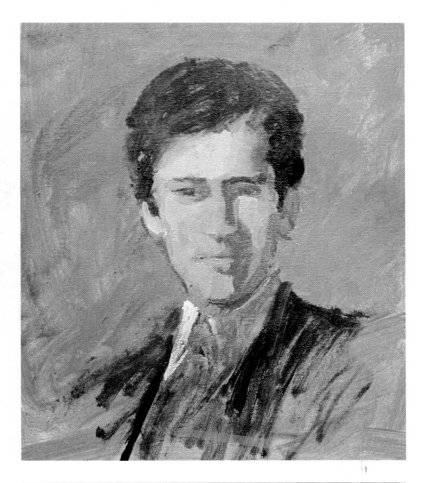

Step 3. A bristle brush lays in the lights with a thick, creamy mixture of raw umber, raw sienna, Venetian red, and plenty of white. The halftones—made with the same mixture but with less white and more raw umber—are placed between the lights and shadows. You can see these halftones most clearly on the forehead, next to the shadow; in the eye socket on the lighted side of the face; on the bridge of the nose; underneath the cheek on the lighted side of the face; and on the chin. The dark area of the hair is now completely covered with rough strokes of burnt umber and ultramarine blue. The same color suggests the jacket. A few strokes of white faintly tinted with raw umber indicate the lighted planes of the collar, while the shadow areas are suggested with cobalt blue, raw umber, and white. More white is added to the original background mixture, and this tone is carried over most of the background with a big bristle brush.

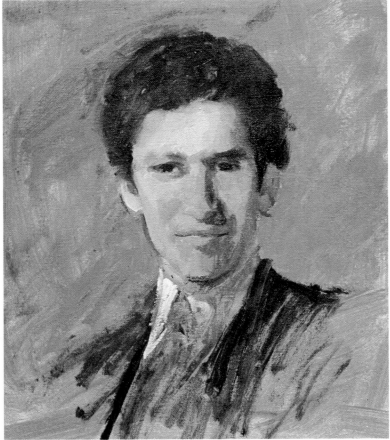

Step 4. A bristle brush begins to blend the lights, halftones, and shadows. The shadows around the eyes, nose, and mouth are strengthened with strokes of raw umber, raw sienna, Venetian red, and white. The halftones on the nose, cheek, and chin are also strengthened with this mixture, but with more white and less raw umber. A small softhair brush deepens the lines of shadow around the eyes, adds the dark notes within the eyes, and strengthens the darks of the eyebrows. These darkest notes are simply the hair mixture. The shadowy tone of the upper lip is redrawn, and then a dark shadow line is drawn between the lips. Work also continues on the background, which is now enriched with a warmer, deeper mixture of burnt umber, cadmium red, and white.

Step 5. A small bristle brush continues to solidify the shadows with a creamy mixture of raw umber, raw sienna, Venetian red, and white. This tone is applied with direct, simple strokes that move down the shadow side of the face, starting with the eye socket and then moving on to the nose, the shadow cast by the nose on the upper lip, the upper and lower lips, and finally the jaw and chin. A slightly paler version of this tone darkens the eye socket on the lighted side of the face and strengthens the shadow on the lower lid. A few thick touches of light are added to the lighted areas of the forehead and cheeks. Compare this step with Step 4 and you'll see that the shapes of the shadows are now more solid and distinct. You can also see the first touches of light on the hair.

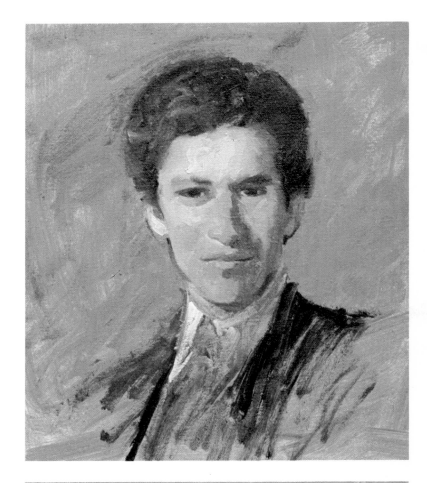

Step 6. Small brushes begin to build up the lights on the face, adding thick, creamy strokes to the forehead, cheeks, nose, lips, and chin. This pale tone is still the basic flesh mixture of raw umber, raw sienna, Venetian red, and white—but the mixture is now *mostly* white. More white is added to the hair mixture, and this tone is blended into the lighted side of the hair. A small brush darkens the corners of the lips and strengthens the darks at the corners of the eyes. Then the tip of a round softhair brush draws the dark lines of the eyelids more precisely, adds the dark pupils (with the hair mixture) and finally adds the whites of the eyes and the highlights on the pupils with pure white tinted with a minute touch of skin tone.

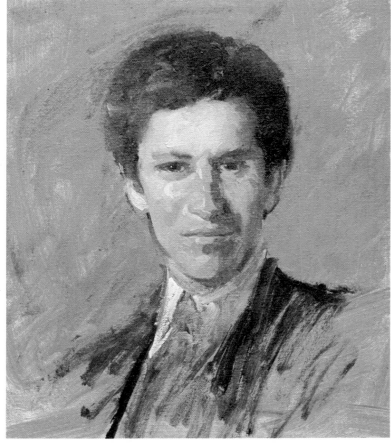

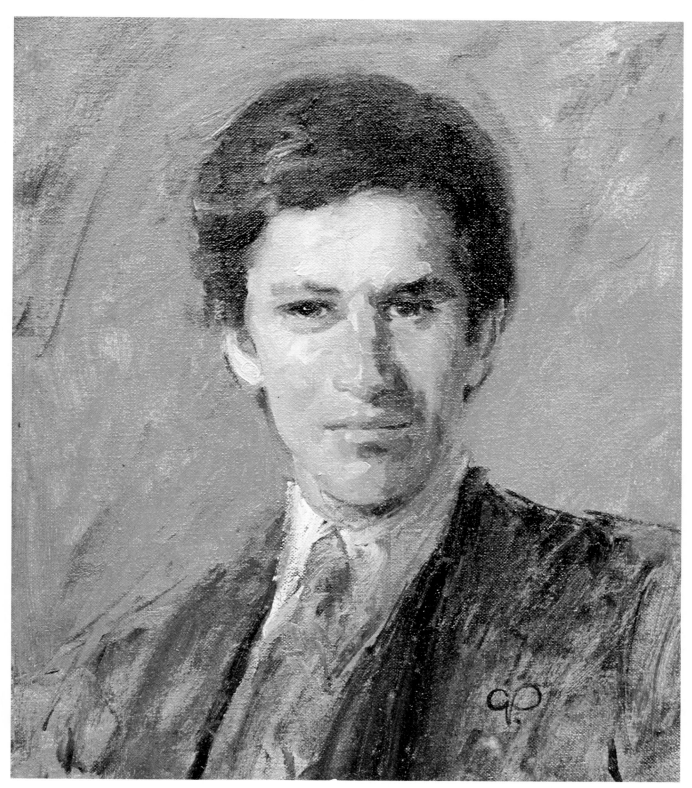

Step 7. Small brushes move over the face to add the last *accents* of light and dark that make the portrait more vivid and alive. Extra touches of darkness are added to the eyebrows, the corners of the eyes, the nostrils, and the corners of the lips. These darks are the same mixture as the hair tone, with just a little Venetian red. Extra dashes of shadow are carefully placed between the lips, beneath the lower lip, and beneath the chin. Thick, juicy touches of light are added with thick strokes above the eyes and with tiny strokes around the lips. More strokes of light are blended into the hair, while the hair mixture is used to complete the jacket. Touches of cobalt blue, raw umber, and white suggest the tie—without painting it completely. And the corners of the background are darkened with raw umber to make the head seem surrounded by a warm glow.

Step 1. A rag tones the canvas with a mixture of ultramarine blue, burnt umber, and white diluted with plenty of turpentine. A darker version of this same mixture, but with less turpentine and no white, is used to make the preliminary brush drawing. The outer contours of the face are drawn first, and then the brush indicates the loose curls with quick, scrubby strokes. The eyes of the sitter are particularly magnetic, and they're drawn with greater care than one would normally take in a preliminary drawing. A few strokes define the nose and mouth. The brush begins to indicate the shadows on the face and neck with very light tones—diluted with a great deal of turpentine—and the light areas of the face are wiped away with a rag wrapped around a fingertip. Just a few strokes define the shoulders and the neckline.

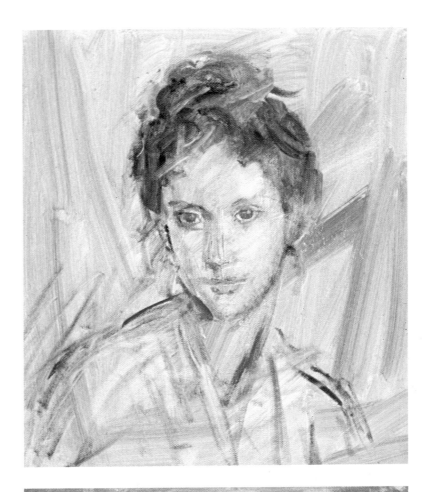

Step 2. A big bristle brush covers the background with a thicker version of the original mixture: ultramarine blue, burnt umber, and white, diluted with painting medium—not just turpentine. A smaller bristle brush places the shadows on the brow, cheek, jaw, chin, neck, eye socket, nose, and lips. This shadow tone is a mixture of raw umber, cobalt blue, and white. Study the eye socket on the shadow side of the face: the upper eyelid catches the light, while the lower eyelid is in shadow. Conversely, the upper lip is in shadow because it turns away from the light, while the lower lip turns upward and catches the light. The dark side of the hair is indicated with a dark mixture of burnt umber and ultramarine blue.

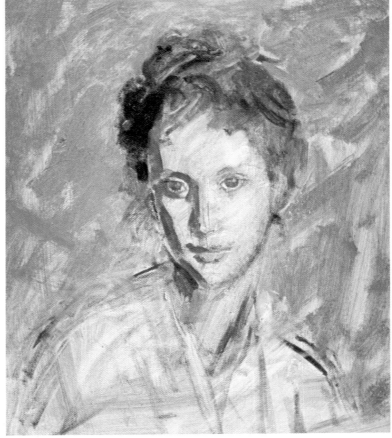

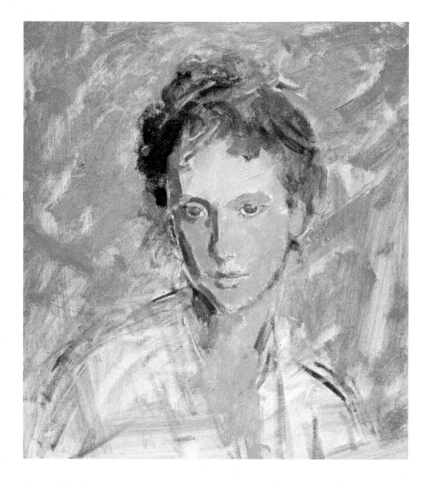

Step 3. The light planes of the face are covered with broad strokes of raw umber, Venetian red, raw sienna, and white. Notice that the lower half of the face is a bit darker than the forehead; these darker tones contain slightly less white. The first halftones begin to appear in the eye sockets, along the lower jaw, and beneath the chin. These halftones are a slightly darker version of the flesh mixture—to which a minute quantity of the background color has been added. The light tone is carried down the neck and over the chest. A halftone is placed directly beneath the chin. Some background color is also brushed into the hair. Observe how these light areas all grow slightly darker where the rounded edges of the forms turn away from the light.

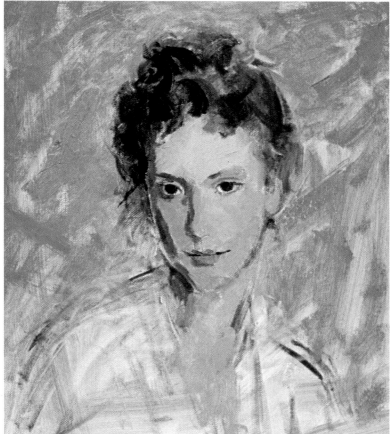

Step 4. Working with a slightly darker version of the original flesh mixture, stronger halftones are added on the front of the nose and chin and along the lighted edge of the face next to the ear. The eye sockets are darkened, and then the tip of a round brush adds the dark lines of the eyelids. The darks within the eyes are added with the original hair mixture of burnt umber and ultramarine blue. Cadmium red is added to the flesh tone to block in the tones of the lips. A slightly paler version of this color suggests the ear on the shadow side of the face. And a big bristle brush begins to indicate the curls of the sitter's hair. A round brush begins to add linear details like the eyebrows and the dark corners of the mouth.

Step 5. A big bristle brush works on the lighted top and side of the hair with ultramarine blue and burnt umber, lightened with just a touch of white. On the shadow side of the face—particularly on the cheek—the halftones are enriched with more raw umber and Venetian red. This warm color is also brushed into the lighted cheek. The halftones are strengthened beneath the eyes, within the eye sockets, and along the lighted jaw. The darks of the eyelids are also deepened, and the pupils are added with touches of pure black warmed with burnt umber. The brush begins to blend the lights, halftones, and shadows on the cheeks. So far, the lighted ear is nothing more than a patch of pale color for the lobe and rim, plus a dark patch for the hollow.

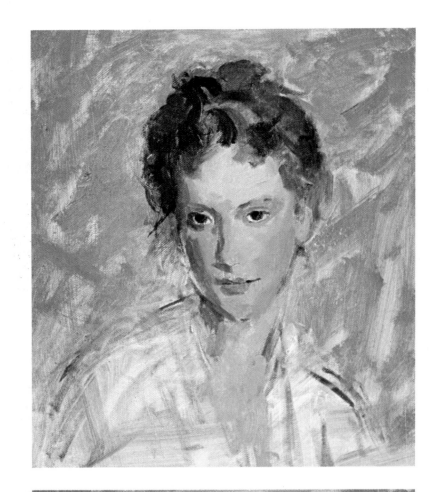

Step 6. A flat softhair brush blends the darks and halftones on the shadow side of the face and then darkens the eyelids with the shadow mixture. The lips are shaped more carefully, darkening the upper lip and placing a shadow beneath the lower lip. The shadow beneath the nose is carried downward to the lip. A pointed brush begins to add details like the eyebrows, the dark lines of the upper lids, the whites of the eyes, and the dark contours of the nostrils. A shadow is added where the hair overhangs the forehead. The shadow on the neck is pulled downward, and the chest is darkened to a halftone. In addition to the original components of the flesh mixture, all these darker notes contain a small quantity of the background color.

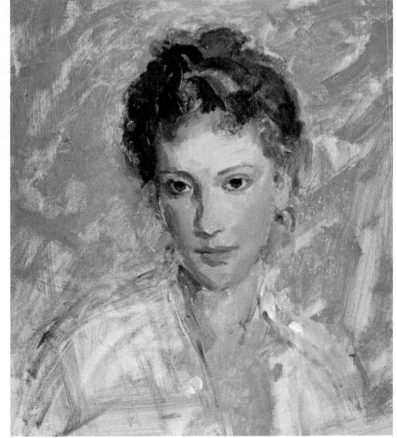

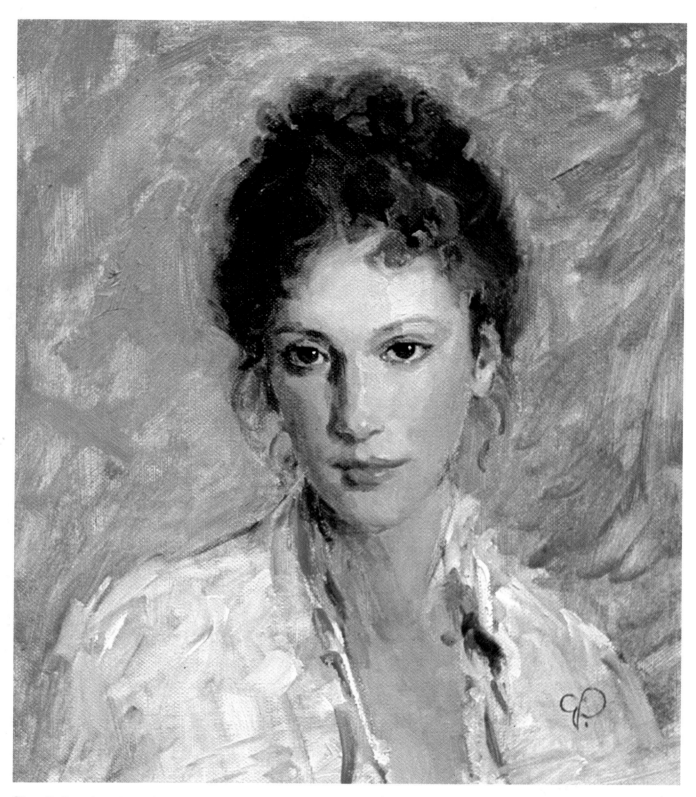

Step 7. Broad strokes of ultramarine blue, burnt umber, and white cover the background. A small, round brush suggests individual curls and then adds highlights to the hair with ultramarine blue, just a little raw umber, and white. More white is added to the flesh mixture to build up the lights on the forehead, cheeks, and chin. A round brush picks up this mixture to add highlight to the nose and lips. The same brush lightens the upper lids and darkens the shadows beneath the lids; defines the nostrils more precisely; and then softens the lines of the lips. A flat softhair brush moves gently over the face, softening such contours as the eye socket and the lower lip; blending lights and halftones; adding hints of warm color to the chin and the hollow of the ear; and blurring the shadow on the neck. Strokes of white tinted with background color complete the blouse.

Step 1. A mixture of cobalt blue and just a hint of raw umber diluted with plenty of turpentine is wiped over the canvas with a rag. Then the preliminary brush drawing is made with pure cobalt blue diluted with enough turpentine to make the paint handle like watercolor. This brush drawing is interesting because it emphasizes broad patches of light and shadow. The domelike shape of the hair is a solid tone. The dark eye sockets are also filled with tone, as are the shadow planes beneath the nose, lower lip, and chin; the dark planes where the cheeks and jaw turn away from the light; and the shadow cast by the chin on the neck. Now work begins on the darks of the hair just above the ears with a mixture of ivory black, ultramarine, and burnt umber.

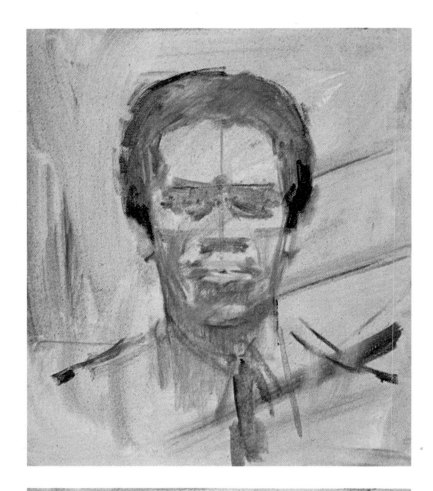

Step 2. The hair is the darkest note in the portrait, so the tones of the hair are placed first with ivory black, ultramarine blue, and burnt umber. Now it will be easier to determine all the other tones in the portrait, since even the darkest of these tones must be lighter than the hair. The darks of the face—first indicated in Step 1—are now solidified with heavier strokes of burnt umber, ultramarine blue, a little cadmium orange, and white. These rich darks contrast beautifully with the lighted planes of the face. The head already looks boldly three-dimensional. Thicker background color—cobalt blue, raw umber, and white diluted with medium—is brushed in above the shoulders and around the face. The collar and tie are suggested with a darker version of this color containing less white. A stroke of white is placed on the lighted side of the collar.

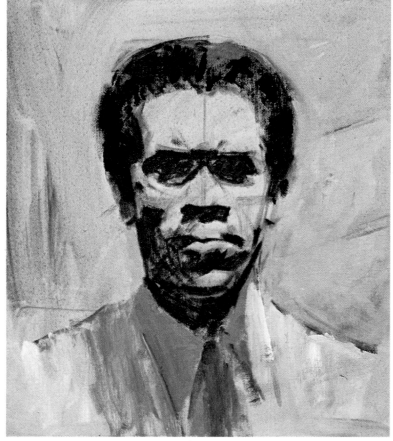

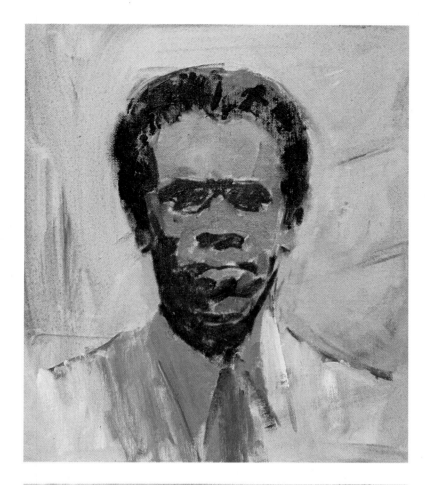

Step 3. The lighted planes of the face are placed beside the darks. These lights are a blend of burnt umber, ultramarine blue, cadmium orange, and white. The forehead receives the strongest direct light, so this plane is a little paler than the lower half of the face. A warmer shadow tone is brushed over the darks, which become richer and more solid. The shadow mixture is also burnt umber, ultramarine blue, cadmium orange, and less white. These shadow shapes are very carefully designed to reveal the form. Study how the shadow runs down the side of the face, curving in with the brow, cutting under the cheek and into the corner of the mouth, and then moving under the lip and chin. On the brightly lit forehead, notice how the color darkens slightly at the curving edge of the form.

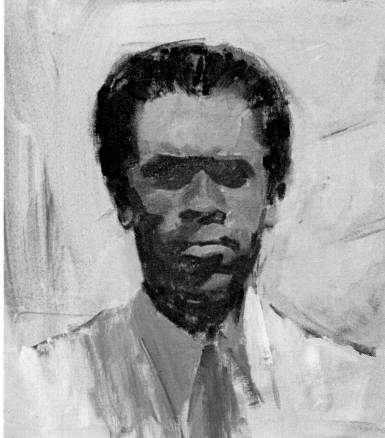

Step 4. More white is blended into the shadow tone to produce the halftone mixture. Then halftones are added between the light and shadow— along the lower edge of the brow, on either side of the nose, on the cheeks, and on the lips. The brush begins to blend the edges of the halftones where they meet the light. In this boldly painted head, all the work is done with bristle brushes. Just as softhair brushes add delicacy to a female face, bold strokes of a bristle brush can accentuate the strength of a masculine face.

Step 5. More white is blended into the basic flesh mixture of burnt umber, ultramarine blue, cadmium orange, and white. Just enough medium is added to make this mixture rich and creamy. Then a bristle brush begins to emphasize those areas that catch the most light—the forehead, cheek, bridge of the nose, and upper and lower lips. Another brush blends the edge where the lighted forehead meets the dark shape of the hair; some cool background color is blended in at this point.

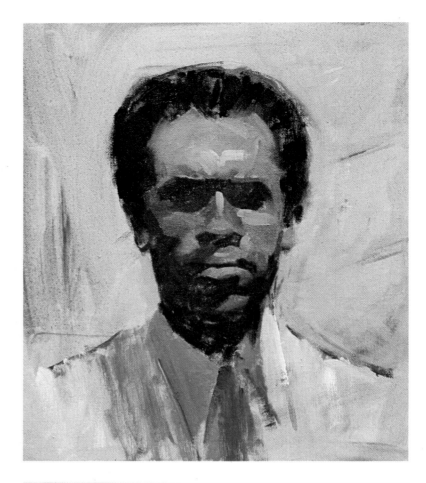

Step 6. The dark strokes of the hair are fused into one soft, continuous tone. The outer edge of the hair is blended softly into the background. Stronger lights are added to the forehead, cheek, nose, and lower lip with thick strokes. The brush begins to blend the edges of the shadows, which now melt softly into the halftones; you can see this most clearly around the eye socket, on the shadowy cheek, and around the mouth. A small brush begins to add details such as the whites of the eyes—which are almost as dark as the halftones—and the darks of the eyes, which are the shadow mixture. A softhair brush blends a touch of Venetian red into the shadows to add a hint of warmth beneath the nose and on the jaw. The shadow on the neck is blended into one continuous tone.

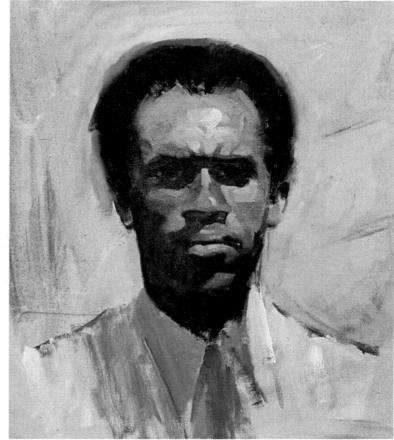

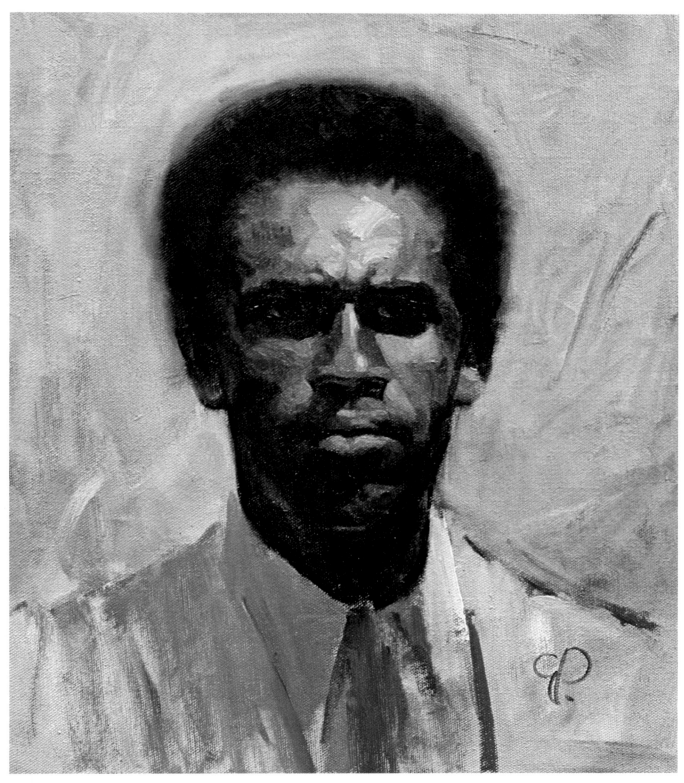

Step 7. In this final stage, a small brush strengthens the darks around the eyes, ears, nose, and mouth with a mixture of ultramarine blue and burnt umber. The eyebrows, the nostrils, the hollows of the ears, and the line between the lips are all sharpened with precise strokes of this mixture. The shadows are warmed with touches of Venetian red, which you can see most clearly on the cheek, jaw, and chin. Touches of cool background color are also blended into the shadows beneath the eyes, nose, and lower lip. The portrait captures the beautiful interplay of warm and cool color which is typical of black skin.

Step 1. The canvas is toned with a blend of raw umber and raw sienna that creates a warm, golden tone that harmonizes with the sitter's skin. The same mixture, but containing more raw umber and less raw sienna, is used for the brush drawing of the head. The brush draws the curving outline of the oval face, the curves of the neck and shoulders, and the dark shape of the hair. Then the eyes are located with dark touches; the nose is indicated with a single stroke that travels down the shadow side, plus quick touches for the nostrils; and the lips are suggested with broad, horizontal strokes. The shadow on the neck is lightly scrubbed in, and then the light areas of the neck are wiped away with a rag wrapped around a fingertip. The background is darkened with the same tone that's used for the brush drawing.

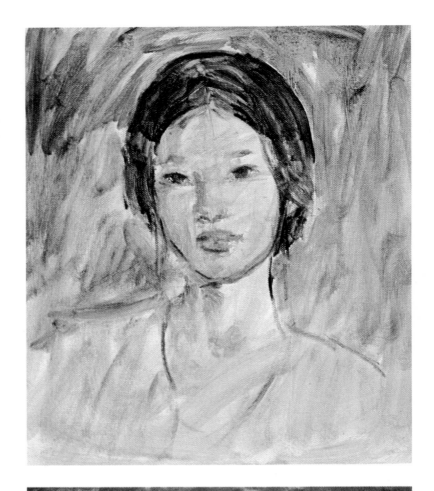

Step 2. The background is roughly covered with broad strokes made by a big bristle brush. The brush carries a mixture of cobalt blue, raw umber, raw sienna, and white. This cool tone will contrast nicely with the golden tone of the sitter's skin. It's important to establish this color scheme in the early stages of the portrait so you can judge the skin mixtures more accurately.

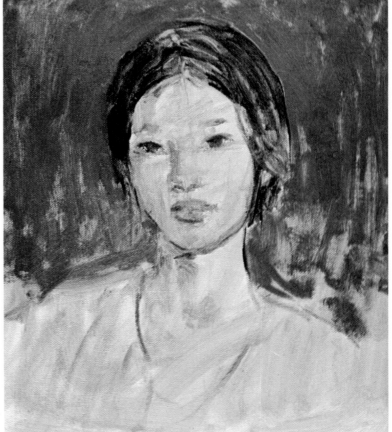

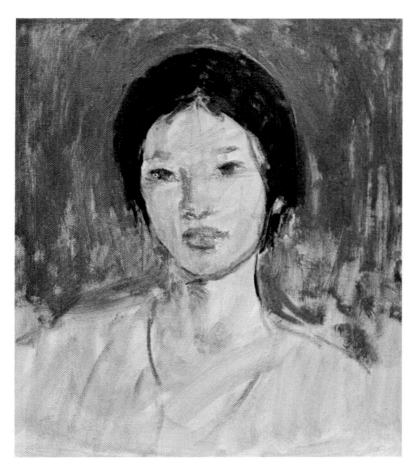

Step 3. The rich, dark shape of the hair is covered with strokes of ivory black, ultramarine blue, and a hint of burnt umber. A slight touch of light is suggested on the hair by adding more ultramarine blue and white to this blackish mixture. A rag wipes away some tone from the lighted side of the face.

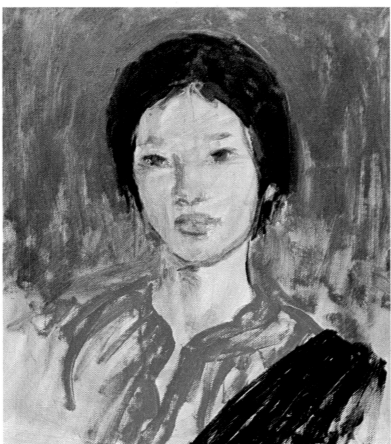

Step 4. Now the brilliant color of the dress is begun with strokes of cadmium red and alizarin crimson—which yield a particularly vibrant red—softened with a touch of cobalt blue and white. The dark fabric, draped over the sitter's shoulder, is painted with strokes of the hair mixture: ivory black, ultramarine blue, and burnt umber. Now the face is surrounded by all the colors which will contrast with the skin tones. This will make it easier to mix the skin tones and judge them accurately as they're placed on the canvas.

Step 5. The darks of the eyes are carefully painted with the tip of a round softhair brush that carries the hair color. Because the contrast between light and shadow—in the final portrait—will be particularly subtle, the artist starts work on the lights and shadows at the same time. The lighted side of the face is covered with a pale mixture of raw sienna, cadmium yellow, cadmium red, and white. The shadows on the brow, eye socket, nose, lips, and neck are painted with small touches of raw sienna, burnt umber, and white. At this early stage the face already contains a suggestion of the lightest and darkest notes that will appear in the finished portrait.

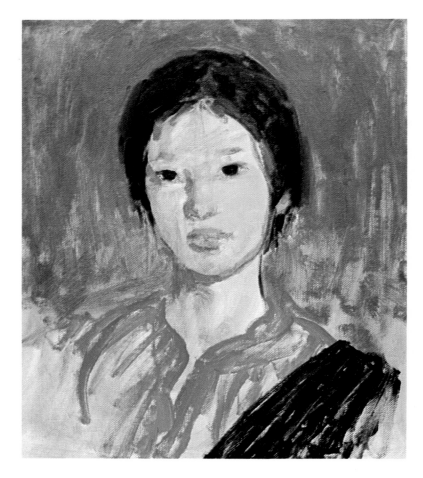

Step 6. Most of the face is just slightly darker than the light areas painted in Step 5. The forehead, nose, chin, and the shadow sides of the face and neck are covered with broad strokes of the same flesh mixture that appears in Step 5: raw sienna, cadmium yellow, cadmium red, and white. But now the mixture contains less white and more raw sienna. The dark drapery on the shoulder is distracting, and it's covered with a more delicate mixture of cobalt blue, alizarin crimson, and white, scrubbed on with rough strokes of a big bristle brush. A few strokes of this mixture appear on the opposite shoulder. Work continues on the background, where the original strokes are blended and brushed more evenly over the entire area. At the same time a few hints of the clothing mixtures are blended into the background above the shoulders. The area of the red dress is broadened with more color.

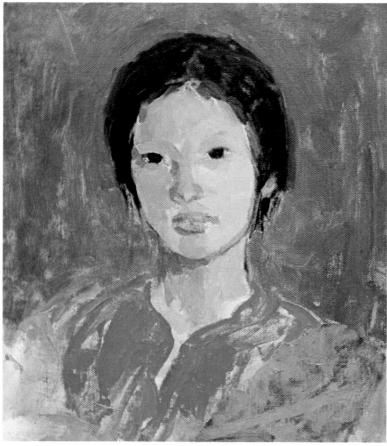

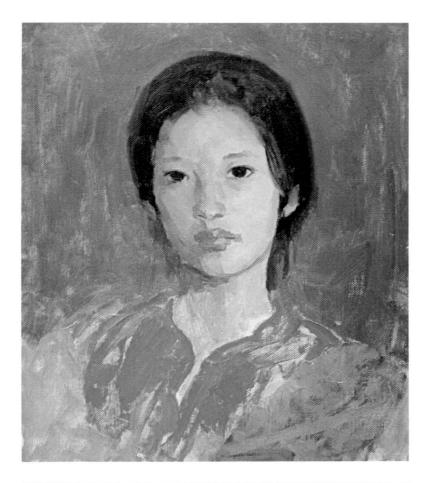

Step 7. Shadows and adjacent halftones are carried down the shadow sides of the brow, cheek, jaw, chin, nose, and lips. These "dark" notes are really not much darker than the lighter skin tones painted in Step 6. The components of the mixture, once again, are raw sienna, cadmium yellow, cadmium red, and white—with more raw sienna and less white. More cadmium red is blended into this mixture to add color to the lips. Patches of light and shadow are added to the ears. A pointed brush begins to darken the eyebrows and the shadowy edges of the eyelids. A flat, softhair brush blends the strokes of the hair into one continuous tone and softens the edges of the hair where they meet the background color. A pointed brush picks out a few strands of hair next to one ear.

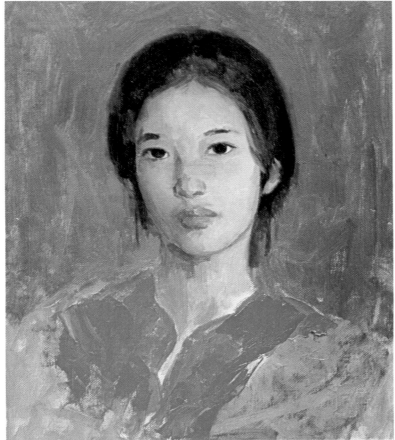

Step 8. A flat softhair brush begins to blend lights, halftones, and shadows. As these tones flow smoothly together, the face becomes rounder and more luminous. The shadow beneath the chin is carried down the length of the neck, and a touch of darkness is added just beneath the chin. The tip of a round brush continues to sharpen the eyebrows with the hair mixture and then darkens the upper lids. Notice how the hair is carried down the side of the shadowy cheek, which now stands out more distinctly. The tip of the brush sharpens the contours of the nostril wings, the nostrils themselves, and the lips.

Step 9. Flat softhair brushes begin to accentuate the darks and the lights. Creamy strokes build up the lights on the forehead, cheek, chin, and neck. The darks are strengthened on the shadow sides of the brow, nose, upper lip, and jaw. The contours of the lips are modeled more precisely. The eyebrows are thickened and the rims of the eyes are darkened. The whites of the eyes are added with *almost* pure white tinted with a minute amount of flesh color. The pupils are painted with pure black and the highlights are added with touches of pure white. A darker background tone is mixed on the palette with cobalt blue, raw umber, and less white; this is brushed over the background, concentrating the heaviest tones around the head and simplifying the shape of the hair by eliminating the hanging strands that appear in Step 8.

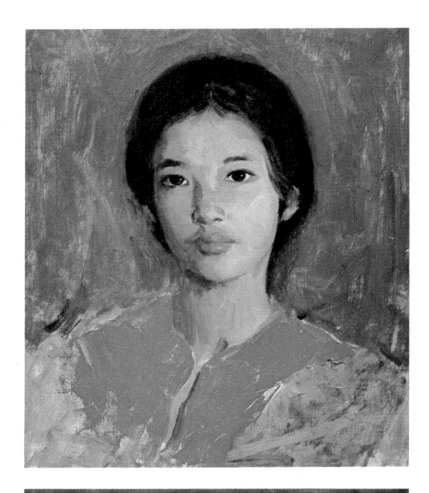

Step 10. Work continues on the background tone, which grows darker and more uniform, although hints of warmer colors still shine through. Softhair brushes continue to darken the shadows and strengthen the lights with touches of thick, creamy color. The face grows darker, richer, and more luminous as the strokes contain more cadmium yellow, more raw sienna, and less white. The shape of the mouth becomes more rounded as the small brush strengthens the shadows and sharpens the drawing. The dark beneath the chin is sharpened to make the chin come forward more distinctly.

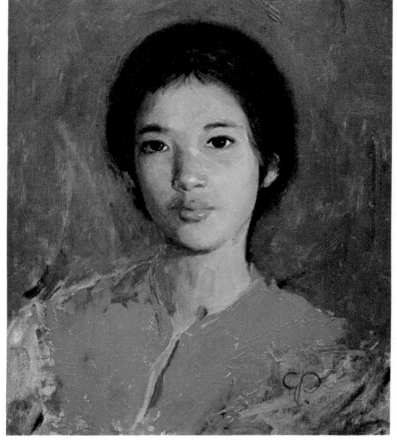

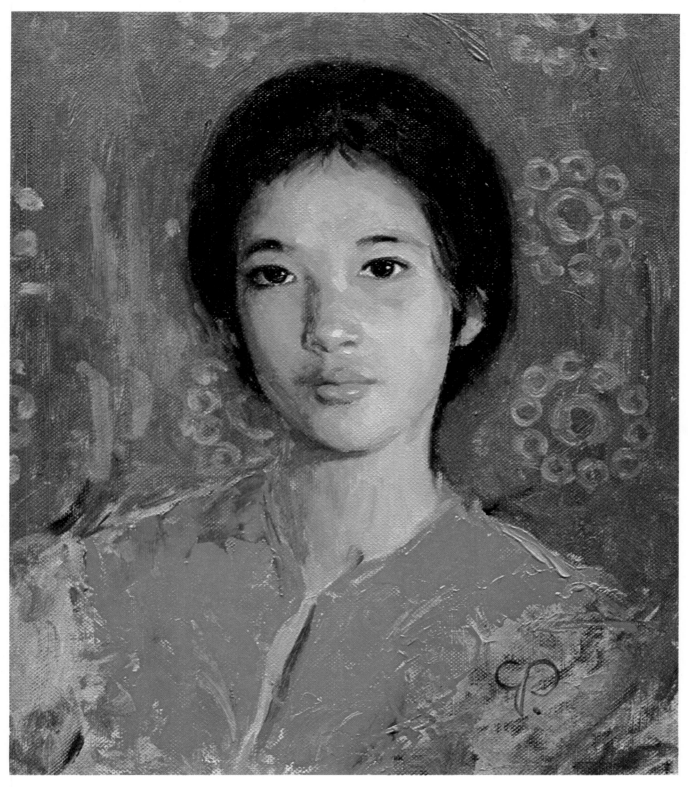

Step 11. The final stage shows how the shadows and half-tones have been enriched with the golden tones of raw sienna and cadmium yellow, lightened with white. Golden highlights of this mixture—with lots of white and painting medium—brighten the bridge of the nose, the tip of the nose, and the lips. Notice how the cadmium red in the shadows adds brilliance and transparency. The background mix-ture is lightened on the palette with white; this tone is drawn into the wet background with the tip of a small bristle brush to suggest the pattern of a fabric behind the sitter's head. Despite the blending action of the softhair brushes, it's im-portant that the flesh tones aren't absolutely smooth; they still retain the marks of individual brushstrokes.

Step 1. The canvas is toned with raw umber. Then some Venetian red is blended into the raw umber on the palette for the brush drawing. The preliminary brush drawing is quite complete, delineating the features with great care and roughly indicating the shapes of the shadows. A rag wipes away some of the wet undertone on the lighted side of the face, neck, and scarf. Rough strokes suggest the pattern of the sitter's jacket. The background behind the head is darkened with free strokes of raw umber slightly darkened with ultramarine blue.

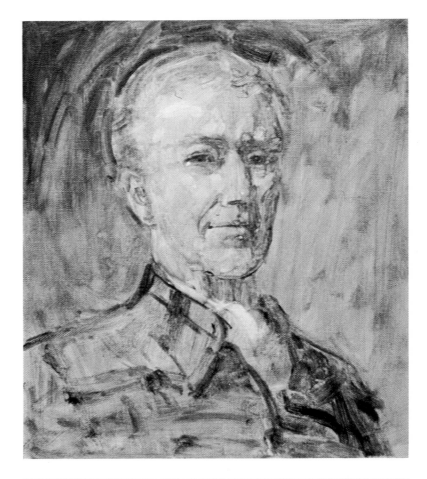

Step 2. A big bristle brush darkens the background with rough strokes of raw umber, ultramarine blue, a touch of viridian, and white. This dark tone silhouettes the head and defines the contours more sharply. A small bristle brush blocks in the shadows with raw umber, Venetian red, and white. As always, the eye socket on the lighter side of the face is lighter than the eye socket on the shadow side of the face. The tip of a round softhair brush places slender lines of shadow beneath the upper eyelids, between the lips, and inside the ear. The same brush adds the darks of the iris with burnt umber, ultramarine blue, and viridian. Work begins on the hair with strokes of burnt umber, ultramarine blue, and white. The first dark notes of ultramarine blue and burnt umber are placed inside the collar.

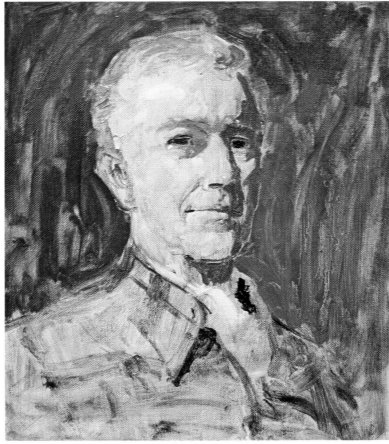

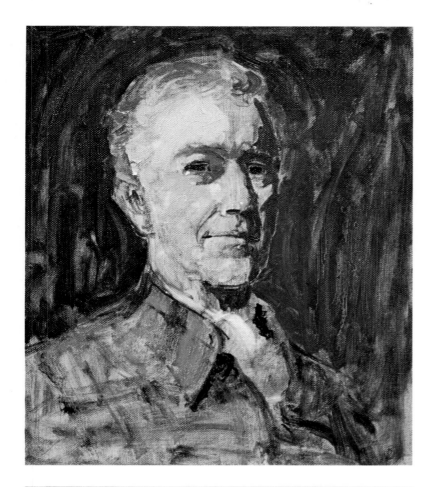

Step 3. At this stage work begins on the lightest areas of the skin. A bristle brush scrubs on a pale mixture of raw umber, cadmium red, and lots of white. The first strokes are placed on the most brightly lit area—the forehead—and then the mixture darkens very slightly as the brush moves down to the cheek. In general, it's worthwhile to remember that the greatest amount of light falls on the upper half of the head, and the tones tend to darken gradually as the brush moves down the face. You can see that the shadow beneath the chin is darker than the shadow on the cheek. More pink is added to the flesh mixture for the lighted edge of the ear. Cadmium red is softened with raw sienna, and the first touches of color are placed on the shirt.

Step 4. The light areas of the face are now completely covered. It's important to notice that the lights are not one continuous tone, but are several different mixtures—starting out with a pale mixture on the forehead, then growing darker on the cheek, and becoming darker still on the jaw, chin, and neck. The ear is darker too. So are the lights on the shadow side of the face. The lighted cheek is raw umber, cadmium red, and white. The slightly darker tones are raw umber, raw sienna, Venetian red, and white. This mixture is used to place a halftone between the lights and shadows in the eye socket on the lighted side of the face, down the front of the nose, and along the underside of the nose. The edge of the jaw is darkened with more raw umber. A few strokes of white, softened with raw umber, appear on the scarf, alongside a touch of cobalt blue softened by raw umber and white.

Step 5. Halftones are brushed in with a lighter version of the shadow mixture—raw umber, Venetian red, and more white. You can see a broad halftone between the light and shadow planes of the forehead, plus varied strokes of halftone around the mouth, chin, jaw, and neck. A small bristle brush begins to blend the halftones into the shadows on the dark side of the face and inside the eye sockets. A whisper of cadmium red is added to this mixture to paint the warm hollows of the ear; the warm corners of the eye, nose, and mouth on the lighted side of the face; and the warm edges of the jaw and chin. Hints of this warm tone also appear on the shadowy cheek. More cadmium red is added to the pale flesh mixture to warm the lighted side of the nose and cheek.

Step 6. The background is covered with a more uniform dark tone of burnt umber, ultramarine blue, viridian, and just enough white to "bring out" the color. Now there's a much stronger contrast between the dark background and the lighted side of the face, which emerges more dramatically from the darkness. The edges of the hair are blended softly into the background, while more lights are added to the hair with ultramarine blue, burnt umber, and white. The brush continues to blend the lights, halftones, and shadows on the dark side of the face. The warm stripes of the shirt are painted with various mixtures of cadmium red, raw sienna, and raw umber, in varying proportions as the stripes grow brighter or more subdued. More raw umber is added to this mixture for the muted stripes, the dark spots, and the shadow side of the shirt. The pointed handle of a brush scratches some pale lines into the wet paint.

Step 7. A small bristle brush adjusts the colors of the face with crisp, distinct strokes that express the weathered character of this handsome head. More white is added to the basic flesh mixture to build up the lights on the forehead, cheek, nose, upper lip, and chin. For the warmer, darker touches, more raw umber and Venetian red are added to the mixture. The lights and darks of the eye sockets are more clearly defined. If you look carefully, you can see where hints of cool color appear within the shadows and on the lighted lower jaw; these are delicate strokes of cobalt blue softened with raw umber and white. The eyebrows are darkened with burnt umber and ultramarine blue. A small brush warms and softens the corners of the mouth and the line between the lips.

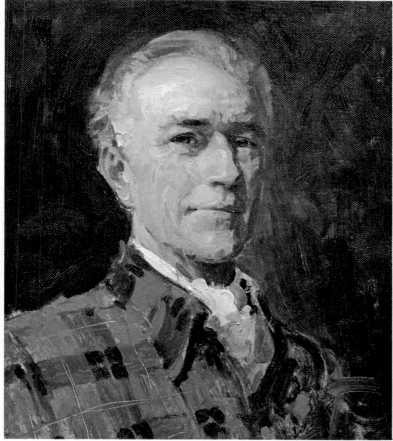

Step 8. A small bristle brush continues to build up the lights with thick, creamy color diluted with just enough painting medium to produce a buttery consistency. You can see the thick strokes at the corner of the forehead, where the form receives the most light; along the bony edge of the nose and further down on the nostrils; on the lighted areas of the cheeks; around the lips and chin; and on the ear. These touches seem to bring the form forward into the light and make the head look more three-dimensional.

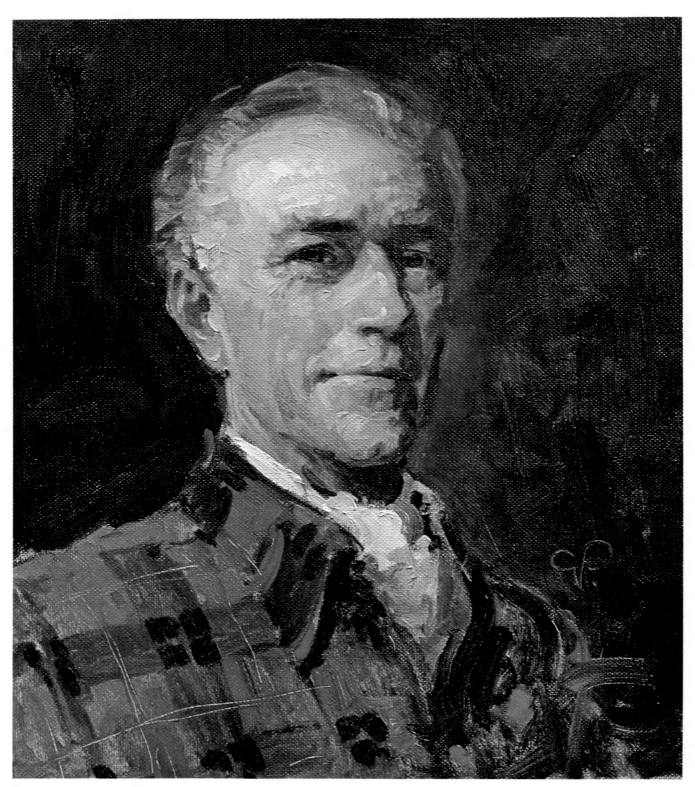

Step 9. In this final stage you can see the last subtle touches that enrich and complete the portrait. The whites of the eyes actually contain cobalt blue and so do the dark tones around the pupils. There are other suggestions of this cool tone in the shadows and halftones. Thick, juicy highlights add luminosity to the brow, the lighted corner of the eye socket, the tip of the nose, the lips, and the chin. These highlights are pure white tinted with a whisper of flesh tone. The background is darkened on the light side of the head to heighten the luminosity of the flesh color. But the background is then lightened on the dark side of the head, making the shadow curve softly into the darkness. Touches of Venetian red add warmth to the shadows, which are as colorful as the lights.

Deciding the Pose. All the painting demonstrations you see in this book are what the professionals call a "head-and-shoulders." This is what you might call the "basic" portrait. It's also the most intimate kind of portrait because it's essentially a close-up of the sitter's face. At first glance, it may seem easy to establish the pose for such a simple portrait—but there are more possibilities than you might think. Above all, try to find a pose that looks *active*, not static. Ask the sitter to lean his head to the left or right. Have the sitter turn—or you walk around him—until you find the most flattering angle. Some sitters will look (and feel) most natural if they slouch or lean in the chair, while others will prefer to sit upright.

Finding the Flattering View. Portrait sitters usually want to be shown at their best. They want you to emphasize their most attractive features and minimize their least attractive ones. Some portrait painters don't hesitate to reduce the size of a big nose, enlarge a small chin, or square up a weak jaw. Other painters consider this "dishonest." Whether you want to flatter your sitter—by redesigning his face—is your decision. However, another method is to try to find the most flattering *view* of the sitter. A big nose looks even bigger if you paint the head from slightly above—but tends to get smaller if you ask the sitter to tilt his chin upward so that you're painting him from slightly below. That same nose may look unattractive in a profile or three-quarter view, but may become strikingly handsome when the sitter faces you head-on. If a sitter is particularly proud of her luxuriant hair, paint her from slightly above so you can see more hair; this view also emphasizes the eyes and de-emphasizes the chin.

Relaxing the Sitter. The whole painting will go more smoothly if you can keep the sitter relaxed and entertained. Watching television, listening to a radio broadcast, or hearing a record will not only reduce the tedium of sitting for a portrait but will make the sitter look alive and alert. After all, if you sitter is tired and bored, it's difficult to keep that feeling out of the portrait. If you can carry on a natural, relaxed conversation with the sitter—without making it obvious that you're trying too hard—that's an excellent way to keep the sitter entertained. The sitter will look at you with an animated expression which will enliven the portrait. Many professionals place a large mirror behind them so the sitter can see how the portrait is coming along—a process more fascinating than *any* television show!

Experimenting With Lighting. The most common portrait lighting is called 3/4 lighting. The light does not hit the face from the front, but hits it slightly from one side; thus *most* of the face is in light, but the angle of the light creates clearly defined shadow planes on one side of the brow, cheek, jaw, and nose. This is often called "form lighting" because it emphasizes the three-dimensional quality of the face. Women often like "form lighting" because it makes a round face look rounder, while men often like it because they feel that the strong contrast between light and shadow makes them look more masculine. On the other hand, there are times when you want to emphasize the softness and delicacy of the face by using frontal lighting. When the light strikes the face head-on, rather than from the side, shadows tend to melt away, softening harsh features and de-emphasizing wrinkles. Move the sitter around—place him or her close to the light, further away, facing the light, facing away—to see how different kinds of light affect each sitter's face.

Making Preliminary Drawings. As you study different poses, angles, and kinds of lighting, it's helpful to make quick pencil sketches of all these possibilities. These don't have to be elegant, finished drawings, or even a good likeness. The drawings simply record all the different options. Spread out the drawings and choose the one that represents the best approach to the final portrait. Having chosen the sketch that looks best, some artists dive right into the painting, while others like to make some more drawings of the sitter—or perhaps a quick oil sketch—before they begin the actual painting. This may seem like extra work, but many professionals consider it a shortcut. As he makes these studies, the artist gets to know the contours of the face so intimately that he can execute the final painting without hesitation.

Some Final Do's and Don'ts. Female sitters often insist on going to the hairdresser just before they come to the studio. The fresh hairdo may have a tight, artificial quality that's much less attractive than the sitter thinks. Ask her to go to the hairdresser a day or two before the sitting, so there's time for the hair to soften and become more natural. If she shows up with a hairdo that's just an hour old, tactfully ask her to soften it slightly with her fingers or with a comb. Ask the sitter to dress simply, preferably in solid colors or clothes with a subdued pattern. Urge the sitter to avoid ornate jewelry and violent colors that distract attention from the face. Never tell a sitter to smile; no one can hold a smile long enough for you to paint it. And be sure to let the sitter take a break—for a walk, a rest, a snack—every twenty or thirty minutes.

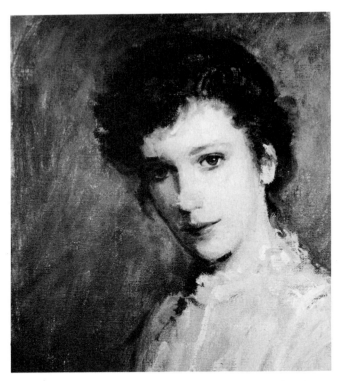

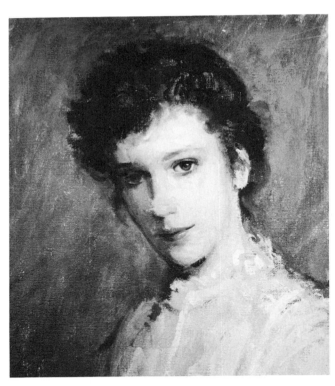

Don't place the head so far to one side that there's a huge space in front of the head and just a little space behind.

Do place the head so the space in front is just a *little* greater than the space behind. It's effective to place the head slightly off center, but not too far to one side of the canvas.

Don't push the top of the head against the top of the canvas and rest the chin against the lower edge of the canvas when you paint a close-up. Such close-ups can be handsome, but the head should never look as if it's crowding the edges of the canvas.

Do allow more space beneath the chin—not hesitating to chop off a bit of hair at the top of the canvas. Now the head is just as big, but the portrait seems more spacious.

Don't crowd the canvas when you're painting a half figure. Once again, the head is too close to the top edge of the canvas and too close to the right side, allowing too much space at the front of the figure.

Do allow enough space above the head and provide a better balance of space on either side of the figure. Now the space in front of the figure is only slightly greater than the space behind.

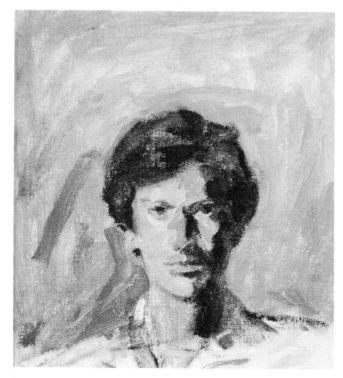

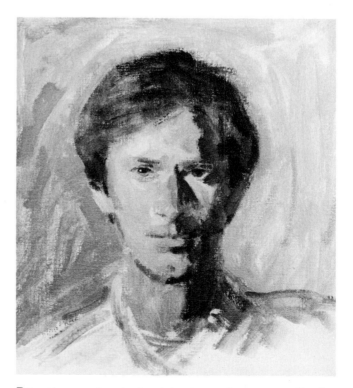

Don't drop the head too far down from the top of the canvas, allowing too much space at either side. In this portrait the space, not the head, dominates the painting.

Do make sure that the head dominates the canvas, allowing a *reasonable* amount of space at the top and the sides.

3/4 Lighting. Sometimes called *form lighting*, this is the favorite lighting of most portrait painters. The light comes from one side and from slightly in front of the face. As you stand at the easel, facing this sitter, the light is coming from somewhere beyond your left shoulder, illuminating roughly three quarters of the head and creating strong shadows on one side of the nose, lips, brow, cheek, jaw, chin, and neck. The shadow side of the face isn't *completely* dark, but catches a certain amount of light on the cheek and jaw. Portrait painters like this kind of lighting because the light and shadow planes are clearly defined, making the forms look solid. Like the face, the hair also has distinct planes of light and shadow.

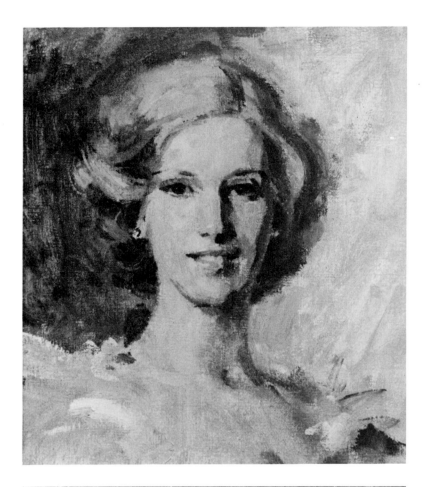

3/4 Lighting. Here's another example of 3/4 lighting, but this time the light comes from your right side. The light source is slightly further to the side, creating deeper shadows on the dark side of the head. In contrast with the woman's head above, the eye sockets are darker, and there are broader shadows on the side of the nose, mouth, and chin. On the lighted side of the face, the eye socket is also in shadow, but the shadow isn't as deep as the tone that fills the eye socket on the dark side of the face. These strong shadows can be particularly flattering to a male sitter. Compare these with the slender shadows that are more flattering to the female sitter.

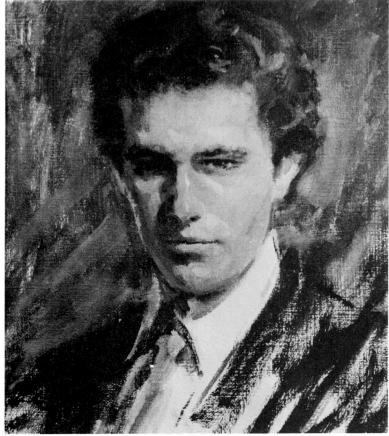

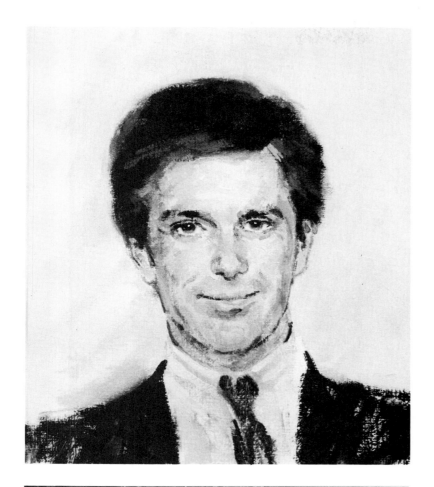

Frontal Lighting. When the light hits the sitter in the center of his face, this is called frontal lighting. As you stand at the easel, facing the sitter, it's as if the light source were your own face, pointing straight at him. Frontal lighting bathes the face in a smooth, even light that minimizes shadows. The shadow planes of the head are only slightly darker than the light planes. The darks tend to be the features themselves: eyebrows, eyelids, eyes, nostrils, and the lines of the lips. Frontal lighting is particularly effective when you want to minimize wrinkles and other surface irregularities in the sitter's face.

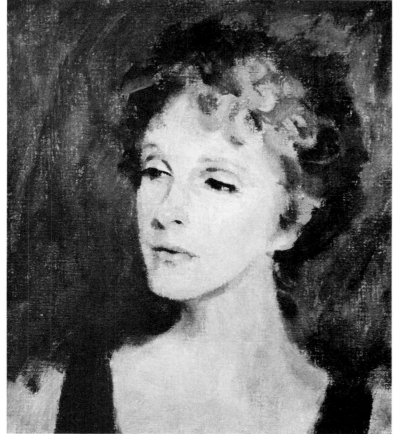

Frontal Lighting. When the sitter turns, frontal lighting may produce slightly more shadow. Hints of shadow appear in the eye sockets, beside the nose, around the lips, and beneath the chin. These shadows, however, are still inconspicuous and not much darker than the lights. The face still looks bright, smooth, and evenly lit. Frontal lighting can be particularly flattering to a female sitter, emphasizing her smooth, soft complexion. The dark background heightens the luminosity of her skin.

Side Lighting. When the light comes directly from the side—as if the sitter is next to a window—the face tends to divide into equal planes of light and shadow. For this reason side lighting is sometimes called half-and-half lighting. In a head-on view of the sitter, the dividing line tends to be the nose: on one side of the nose the face is in bright light; on the other side the face is in deep shadow. A suggestion of light sometimes creeps into the cheek on the shadow side of the face, as you see here. Side lighting will dramatize a sitter who has a strongly cut head and bold features.

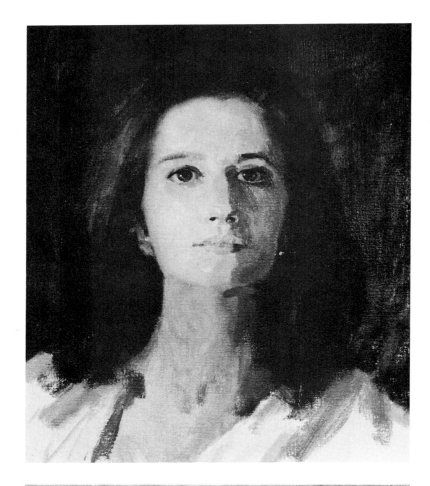

Side Lighting. As the head turns, the distribution of light and shadow may change. Here the dividing line is still the nose, but there's more shadow on the forehead, chin, and neck. In fact there's more shadow than light on this face. Within the deep shadow, there are still subtle variations in tone: patches of darkness around the eyes, nose, and mouth; and a suggestion of reflected light on the cheek. Light sometimes bounces off a reflecting surface such as a white wall, adding luminosity to the shadow side of the head.

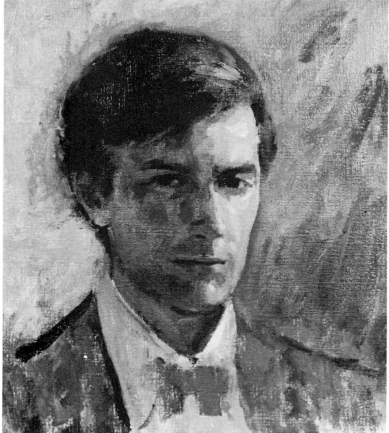

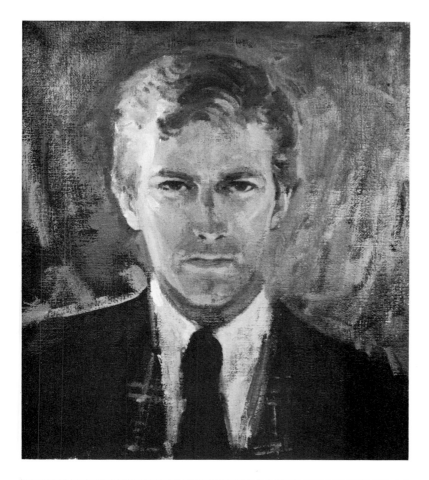

Rim Lighting. When the light source is behind the sitter's shoulder, most of the face is apt to be in shadow. Some of the light, however, usually creeps around one side of the face, which is why it's called rim lighting. Here, the light catches only the very edge of the brow, cheek, ear, and jaw. The rest of the face is in shadow, but this doesn't mean that the front of the face is pitch black. On the contrary, there are still tonal variations that define the features. In rim lighting the lights and shadows may appear in unexpected places, so you have to study the head carefully. This head surprises you by picking up reflected light from below. This means that the lower lids, the underside of the nose, and the upper lip catch the light—which is the reverse of the "normal" distribution of lights and shadows. Rim lighting has a theatrical quality that lends an air of mystery to the sitter's face.

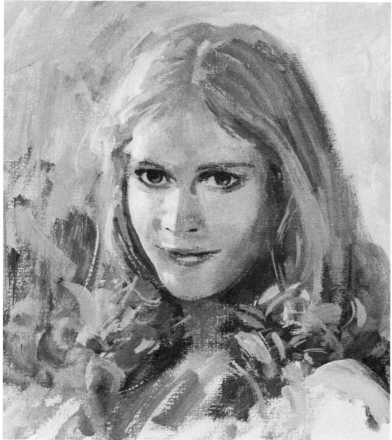

Rim Lighting. As the sitter's face turns toward the light source, the rim lighting may extend beyond the edge of the face to catch the nose, upper lip, and chin. Nor does rim lighting have to be somber and serious, as it is on the male head above. This lighting effect can also be soft and delicate if there's only a slight contrast between the planes of light and shadow. Delicate rim lighting can be particularly flattering to the female head. Here the only strong darks are the eyes and mouth, which look particularly magnetic in contrast with the pale shadow tone that covers most of the face.

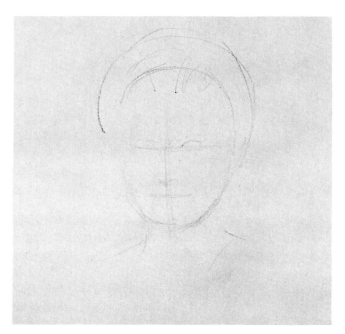

Step 1. A pencil portrait begins with a few strokes for the outlines of the head, hair, neck, and shoulders. A vertical center line divides the head. Horizontal lines are drawn across the center line to locate the eyes, nose, and mouth. A few shorter lines begin to define the features.

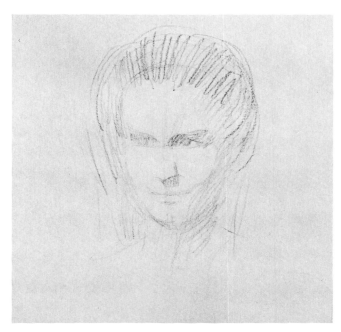

Step 2. Working with pale, parallel lines, the pencil indicates the tones of the hair and the shadows. The eye sockets are filled with shadows. The shapes of the eyes are carefully drawn. Shadows are suggested beneath the nose, beside the nostril "wing," and beneath the upper and lower lips. One broad shadow tone is carried down the side of the head and neck.

Step 3. Still working with parallel strokes, the pencil glides lightly over the paper to darken the hair and the shadows very gradually. The pencil begins to define the darks of the eyes, the nostrils, and the dark line of the mouth. Additional lines sharpen the shoulders and the shape of the dress.

Step 4. Curving strokes continue to darken the hair. The pencil sharpens the contours of the eye sockets with darker strokes, defining the lines of the eyebrows, the lids, and the dark pupils within the eyes. The pencil point darkens the lines between the lips and strengthens the lines of the cheek, jaw, neck, shoulders, and dress. A single line defines the earlobe.

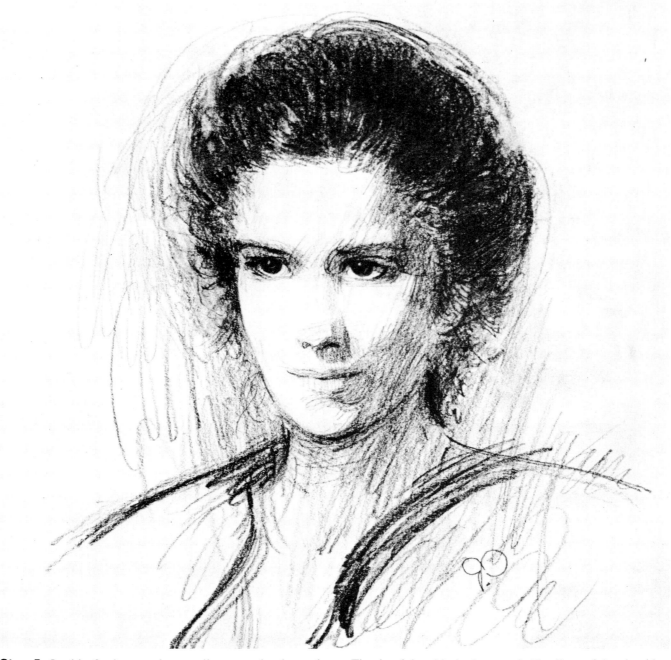

Step 5. In this final stage the pencil presses harder and harder, strengthening and solidifying the darks. The dark strokes of the hair merge to form a continuous tone—within which you can see individual strands. The point of the pencil sharpens and darkens the eyebrows and the eyelids. The sharp corner of a rubber eraser picks out the highlights in the eyes. The pencil point darkens the nostrils and strengthens the shadow at the corner of the nose; the point then moves down to darken the lines of the lips and to strengthen the shadow at the side of the lower lip. Still working with scribbly, parallel lines, the pencil deepens the shadows on the side of the face and carries this tone down to the neck. The tip of the chin is sharpened. The lines of the shoulders and dress are reinforced with multiple strokes. A light tone is scribbled around the head to suggest a background. This method of pencil drawing is particularly interesting because all the tones are made with strokes that follow the form. The strokes of the hair follow the short curves of the sitter's dark curls. The strokes on the face follow the curves of the brow, cheek, jaw, and neck. Although it's *possible* to create tones by smudging the marks of the pencil with a fingertip, all *these* tones are made by building up a network of parallel lines.

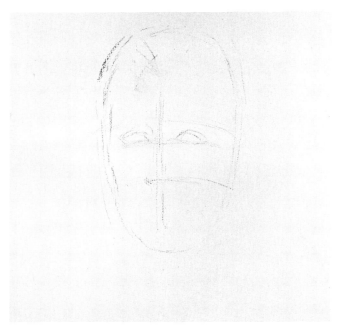

Step 1. The strokes of a charcoal pencil are particularly effective on the textured surface of charcoal paper. This charcoal portrait begins with light, curving lines that define the outer shape of the head and hair. A vertical center line divides the head; then horizontal lines locate the features.

Step 2. Pressing harder against the paper, the charcoal pencil strengthens the outer contours and then draws the shapes of the features. A diagonal shadow runs from the nose to the jaw; another shadow curves down over the brow, cheek, and jaw. These shapes are carefully drawn and then filled with parallel strokes.

Step 3. Moving back and forth over the textured paper, the charcoal pencil gradually darkens the shadows, eyebrows, and mustache. The textured drawing surface tends to produce a ragged stroke. The point continues to sharpen the contours and the features: the eyes, ears, nose, and mouth are more distinct.

Step 4. The point of the charcoal pencil draws some strands of hair and darkens the lines of the features. Now the eyelids are more distinct and you can see the pupils. The details of the ears and nostrils appear. Parallel strokes continue to darken the shadow side of the face and neck.

Step 5. Until now all the work has been done with the tip of the charcoal pencil. But the charcoal inside the pencil is actually a broad cylinder, and you can create rich, heavy strokes by working with the side of the charcoal. Now the side is scribbled over the hair and the shadows, which become darker and rougher as these broad, ragged strokes appear. The collar of the turtleneck sweater is executed by this method. The eyebrows, the mustache, and the shadow of the nose are deepened with broad strokes. And the tip of the charcoal adds the last few dark lines that strengthen the contours of the eyes, nose, mouth, and jaw. Charcoal, like pencil, can be smudged with a fingertip to behave more like paint. But a charcoal drawing is more powerful if you avoid smudging and work with decisive strokes.

Step 1. A chalk drawing can be particularly rich if you work on gray paper with two pieces of chalk, one black and one white. This portrait begins without the usual guidelines for the features. With enough practice you should be able to draw the outer contours of the head and then just strike in a few lines to locate the features, as you see here.

Step 2. The broad side of the chalk begins to surround the head with heavy strokes of darkness. Then the white chalk scribbles in the first suggestion of the light that falls on one side of the face. The bare, gray paper becomes the shadow side of the face.

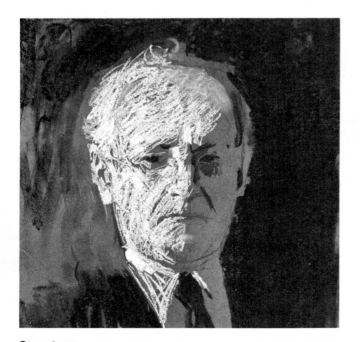

Step 3. The white chalk continues to cover the lighted side of the face with parallel, diagonal strokes, leaving gaps of gray paper for the shadowy eye sockets, the hollow of the ear, and the dark lines of the features. The black chalk continues to surround the head with darkness, scribbles in dark tones for the shoulder and necktie, and then reinforces the features with small strokes.

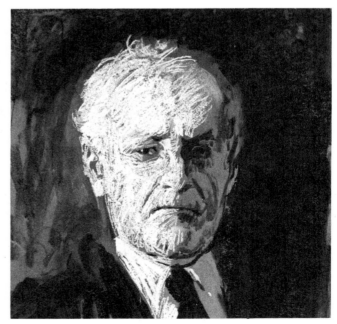

Step 4. The sharp tip of the black chalk delineates the eyebrows, eyes, nose, wrinkles, mouth, and chin with quick, decisive strokes. A touch of white chalk places a single highlight on one eye. A fingertip smudges the strokes of the white chalk to produce a softer, more continuous tone, but doesn't obliterate the individual strokes.

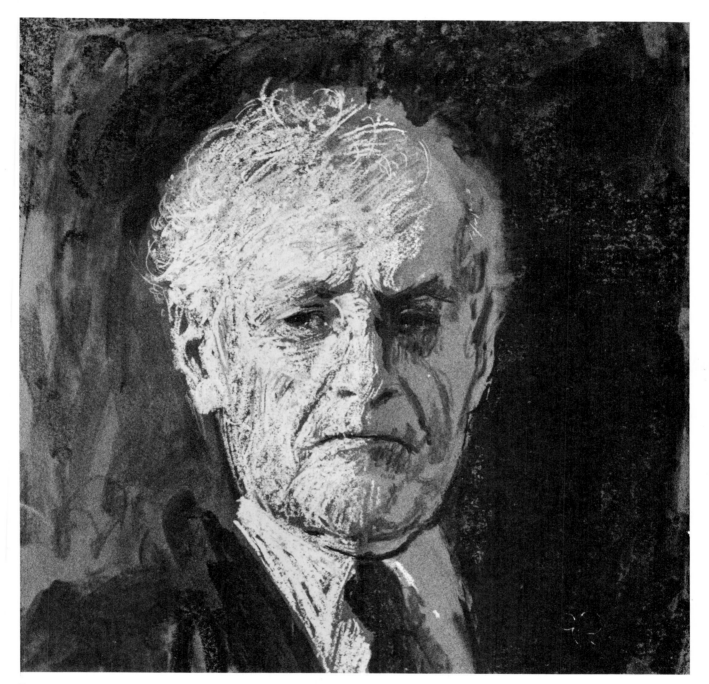

Step 5. The portrait is completed with the sharp points of both chalks. The white chalk adds a few more strands of hair and some touches of white to the eyes. The dark chalk strengthens the shadow lines on the dark side of the face. The "strategy" of this chalk portrait is worth remembering. It's essentially a portrait in three tones. The white chalk creates the lights. The black chalk creates the darks. And the paper provides a middletone that falls midway between the tones of the two chalks. With just a few strokes of the black chalk, the paper becomes the shadow side of the face. Like charcoal, chalk can be used in different ways. The tip can draw distinct lines, while the broad side of the chalk can make wide strokes like a big bristle brush. Working with black and white chalk on gray paper—or with brown and white chalk on tan paper—you can produce a portrait that has a tonal range as rich as a painting.

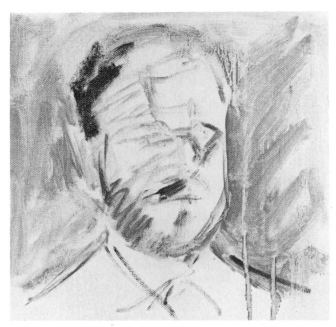

Step 1. To *paint* a preliminary sketch simply mix black and white on the palette to produce a variety of grays—diluted with turpentine. Casual strokes begin by suggesting the background; the dark patches of the hair, beard, and mustache; the shadow side of the face; and the dark eye socket on the lighted side.

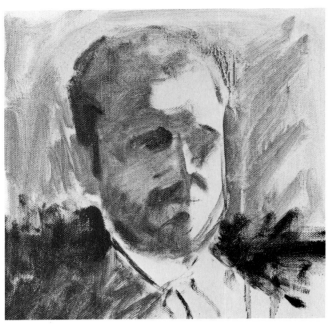

Step 2. The shadow side of the face is covered with one continuous tone. On top of this tone the darker patches are scrubbed in for the hair, beard, mustache, and eye sockets. Another patch suggests the eye socket on the lighted side of the face. Scrubby strokes suggest the shoulders and a landscape background.

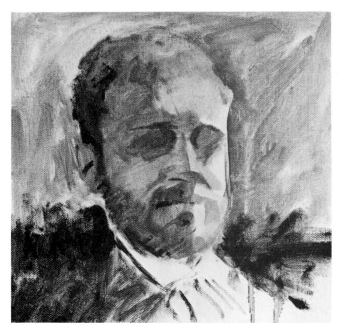

Step 3. A smaller bristle brush adds sharper strokes to define the hairline, ear, jaw line, brows, nostrils, and the dark line of the mouth. Halftones are added to the lighted side of the face—on the forehead, cheek, and jaw. The background is darkened to accentuate the face.

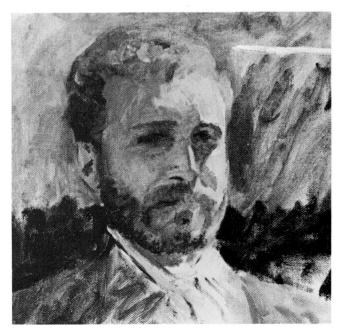

Step 4. Until now, the lights have been bare canvas. Now they're covered with thick, juicy strokes that define the lighted planes of the forehead, cheek, nose, and jaw. The brush begins to blend the brushstrokes on the shadow side of the face. Dark strokes define the features more distinctly and add texture to the beard.

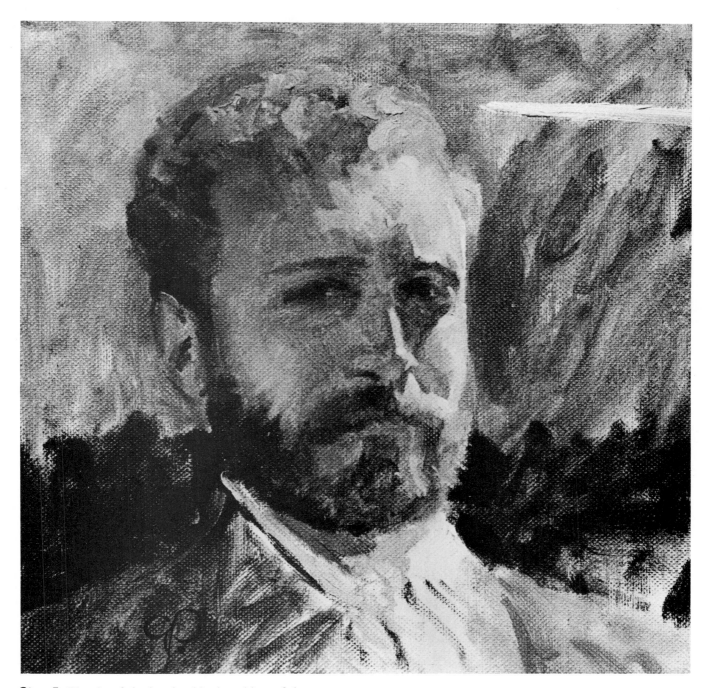

Step 5. The tip of the brush adds the whites of the eyes, sharpens the lighted side of the nose and cheek, and adds details to the lighted side of the beard. Short, thick strokes suggest the texture of the hair. Compare this stage with Step 3 to see how softly the rough strokes on the shadow side of the head have been blended to produce a continuous tone. A rag wipes away some color from the dark cheek to suggest reflected light. Dark color has been scrubbed on the background next to the lighted cheek to accentuate the bright contour. The entire sketch is composed of broad areas of light and shadow, with very little attention to detail. The oil sketch may, in fact, be an excellent likeness—which proves how little detail you need to create a successful portrait, as long as the broad shapes are correct.

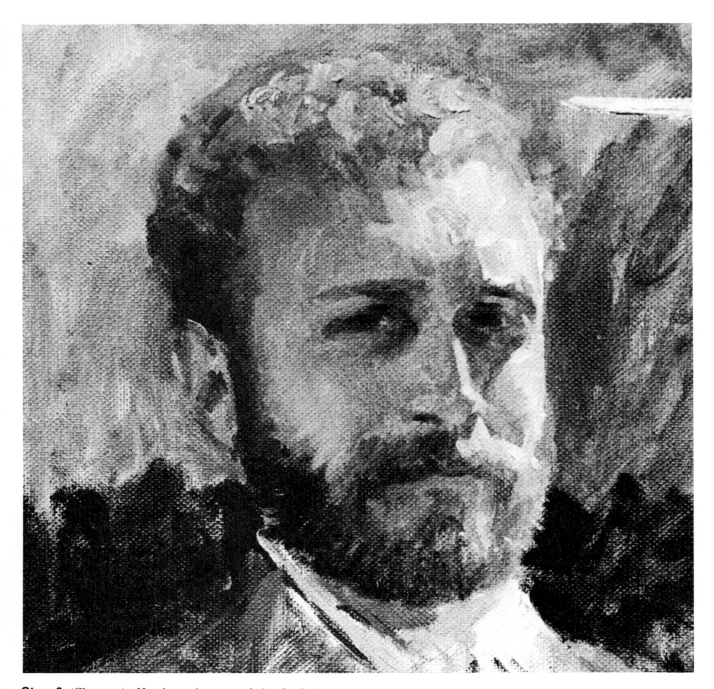

Step 6 (Close-up). Here's a close-up of the final stage, showing the last few refinements in the tones. The corners of the eye sockets are darkened to make them look deeper. Thick highlights are added to the forehead. A few more dark strokes add texture and suggest detail in the mustache and beard. On the lighted side of the forehead, small strokes suggest individual locks of hair caught in the light. The nostril is darkened and the tip of the nose is wiped lightly with a rag to suggest reflected light within the shadow. The artist *could* go on refining the tones and adding more details—perhaps adding color—until the sketch is transformed into a finished portrait. But a successful oil sketch *is* a complete work of art in itself. So it's best to stop here.